IMAGES
of America

ON LAKE WORTH

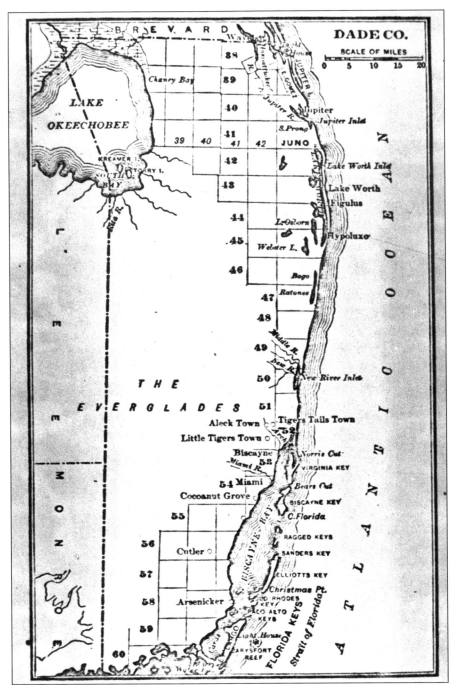

This map depicts Dade County *c.* 1880. Many of the towns' names have changed, such as Figulus, which is today known as Palm Beach. Lake Worth, as shown here, refers not to the present-day city of Lake Worth, but to the 22-mile-long freshwater lake still called Lake Worth today. Until 1909, when Palm Beach County was created, Dade County encompassed the area from the St. Lucie River to the Upper Keys.

IMAGES
of America

ON LAKE WORTH

Beverly Mustaine

ARCADIA

Published by Arcadia Publishing,
an imprint of Tempus Publishing, Inc.
2 Cumberland Street
Charleston, SC 29401

Printed in Great Britain.

Library of Congress Catalog Card Number: 99-61280

For all general information contact Arcadia Publishing at:
Telephone 843-853-2070
Fax 843-853-0044
E-Mail arcadia@charleston.net

For customer service and orders:
Toll-Free 1-888-313-BOOK

Visit us on the internet at http://www.arcadiaimages.com

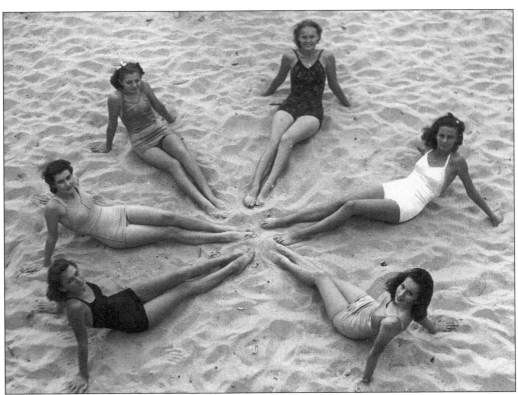

The beach has always been a focal point for social life in Lake Worth and the surrounding communities, and this is still the case today. Young and old alike have many happy memories of hours spent with friends and family at the ocean, the first stop for many winterweary Northern visitors.

CONTENTS

ACKNOWLEDGMENTS

This historical record contains 220 photographs covering a period from 1890 to 1950. The accompanying historical information dates back to the Spanish occupation of Florida. Without exception, the photographs contained herein came from the photographic archive of the Museum of the City of Lake Worth, which contains over 6,000 catalogued photographs. The historical information comes from the Museum's history archives and from the Lake Worth Public Library.

I would like to personally thank the City of Lake Worth for supporting these two valuable municipal resources without which this project would not have been possible. I would also like to thank the donors of the materials and those who have given of their time so that this institution can continue to be available to any and all seeking knowledge.

INTRODUCTION

Florida's colorful history includes explorers, battles, massacres, American Indians, and, at various times, Spanish, French, and English rule. From 1763 to 1784, Spain had traded Florida to England for Cuba, and during the American Revolution, Florida remained loyal to England.

England gave Florida back to Spain in 1784 in exchange for the Bahamas and Gibraltar. St. Augustine, the first settled colony on the Atlantic Coast, founded in 1565, and Pensacola, founded in 1698, were basically the only settlements of consequence when the United States acquired Florida in 1821.

The forms of travel of the day were by steamship or on various small gauge rail lines or crude trails, all involving many delays and discomforts. The Second Seminole War, spanning from 1835 to 1842, made settlement or travel not just inconvenient, but rather hazardous. Nearly 4,000 remnants of various American Indian tribes, referred to as Seminoles, were removed to Arkansas. About 300 retreated into the Everglades.

When Florida became the 27th state of the Union in 1845, the state population was 66,500. By 1861 Florida was the second state to secede from the Union behind South Carolina. The Civil War followed soon thereafter, and Florida proclaimed herself an "independent nation." When the war ended in 1865, Florida found herself in turmoil and remained mostly isolated through the Reconstruction into the late 1870s.

South Florida was the "last frontier" still accessible only by ocean. In the "Lake Worth" area, the 22-mile-long freshwater lake was the safest route between a small settlement near today's Palm Beach and points south to Boynton Beach. A few pioneering settlers lived in the virtual wilderness in huts and shacks. Game was abundant, and the lake was filled with fish and shellfish. Other articles necessary for everyday living were often salvaged on the ocean beach from shipwrecks.

The Homestead Act of 1862 gave 160 acres of land free to settlers willing to live on and improve it for five years. The first claim filed on Lake Worth was in 1872 by Hiram F. Hammon. By 1876 the United States Life Saving Services built five "Houses of Refuge" on the lower East Coast as havens supplied for shipwrecked sailors—such was the frequency of wrecks.

Another small settlement had begun some 60 miles south on Biscayne Bay in Miami. At this point, Dade County encompassed the area from the St. Lucie River in Stuart south to the Upper Keys, nearly a third of the state. County population in 1880 was 527 people in well over 100 miles. Dade County was referred to as the "Great State of Dade." It was not until 1886 in the Palm Beach area that the Lake's first one-room school opened with eight students.

About this time, two former slaves, Samuel and Fannie James, homesteaded a tract that is now the core area of the city of Lake Worth. Fannie became postmistress of the Jewel Post Office, as the area was called at that time. By 1893 eight post offices had been established "on Lake Worth" from Juno to Hypoluxo. In the area there were now four general stores, three small hotels, two boardinghouses, and a weekly paper in Juno.

In 1883 millionaire industrialist Henry M. Flagler and his second wife honeymooned in St. Augustine. Impressed with the beauty and history of the area, he envisioned an "American Riviera." Flagler left home at age 14 with an eighth-grade education. Later, with John D. Rockefeller and Samuel Andrews, he founded Standard Oil, and the rest, as they say, is history. On January 10, 1888, the magnificent Ponce de Leon Hotel opened its doors. Across the street, Flagler built the smaller Alcazar and purchased the Cordova Hotel.

Having invested fantastic sums in these hotels, he needed to assure better transportation for his Northern clientele. He began buying and improving existing railways as necessary, and in 1889 his holdings extended to Daytona Beach. Flagler began moving his railway south, anticipating the tremendous potential for South Florida; appropriately, he named his railway the Florida East Coast Railway.

Rumors began circulating around the Lake early in 1893 that Flagler's railway would soon extend to Dade County and that he would build another great hotel. Soon the rumors were confirmed as Flagler's agents began buying acres in Palm Beach. Many early homesteaders found themselves very wealthy, as orders had been given to buy "at any price." Ground was broken May 1, 1893, and, amazingly, on February 11, 1894, the Royal Poinciana Hotel, the largest wooden structure in the world, welcomed 17 guests.

Flagler's hotel and the railroad had been in a race of sorts, and the hotel had won; however, a month later, the first train pulled in across the Lake at West Palm Beach. Soon a bridge was built across Lake Worth, so the train could deliver her passengers and their private cars at the front door in style. Before years end, West Palm Beach had incorporated. It had a post office, ice factory, stores, town hall, school, and a population of 1,000.

The winter from 1894 to 1895 saw one of Florida's worst freezes. Citrus and vegetable crops were destroyed as far south as Palm Beach. Flagler gave free seed and fertilizer as well as personal loans to growers to get the industry back on its feet rapidly. Soon Flagler became convinced to continue the railroad south to Miami, as they had been undamaged by the frost. Miami pioneers Julia Tuttle and the Brickell family gave Flagler, as an inducement to come to Miami, acres of their holdings as well as river and bay front property for his next great resort. Miami, "The Magic City," was incorporated, the railroad was completed, and the Royal Palm Hotel opened January 1897 in time for the tourist season.

West Palm Beach was named county seat of the new Palm Beach County created by the State from Dade County in 1909. Its boundaries were from the Jupiter area in the north to Boca Raton in the south. Flagler had one dream yet to fulfill. "Flagler's Folly," as it was called, was considered impossible. Flagler wanted to continue the railroad over open water to the southernmost city in the United States, Key West. As Florida's most populous city with 19,000 people, Key West was a valuable naval base and commercial port, as work on the Panama Canal was underway.

Against tremendous natural and engineering odds, including the 1909 hurricane that killed 134 workers, Henry Flagler rode the first train into Key West, "The Island City," January 22, 1912. The following May, Henry Morrison "The Empire Builder" Flagler quietly passed away in Palm Beach.

At this same time, the town of Lucerne, later to be known as the City of Lake Worth, had been platted by the Palm Beach Farms Company, who, a few years earlier, had purchased thousands of acres for sale and development. Bryant & Greenwood of Chicago were hired to promote the area, and they began a nationwide campaign. From across the United States and Canada, families, land seekers, and fortune seekers boarded Henry Flagler's train or traveled on the crudest of roads to Lake Worth for the adventure of their lives.

One
IN THE BEGINNING

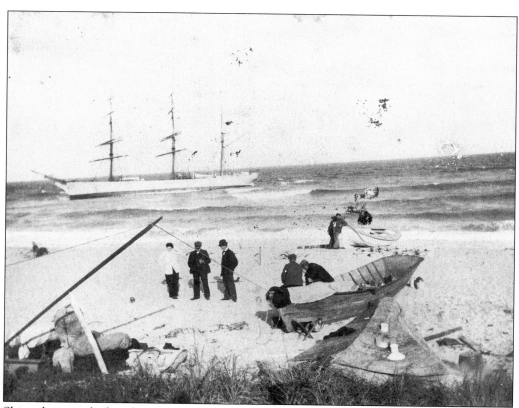

Ships that wrecked and ran aground were frequent for hundreds of years before the earliest settlers arrived. Many early homes were built and furnished with materials washed ashore. Anything from baby buggies to drums of lard might be salvaged. Several merchant ships sailed the Lake visiting settlements too small to support a general store.

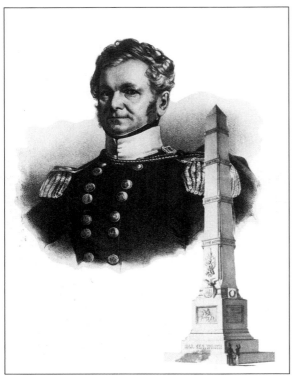

The lake and the city were named after Major General William Jenkins Worth. Worth was the eighth and last general sent to Florida to end the Second Seminole War, fought from 1835 to 1842. Worth Avenue in Palm Beach and Ft. Worth, Texas, also bear his name. He is shown here with his 51-foot granite monument located at Broadway and Fifth Avenue in New York City.

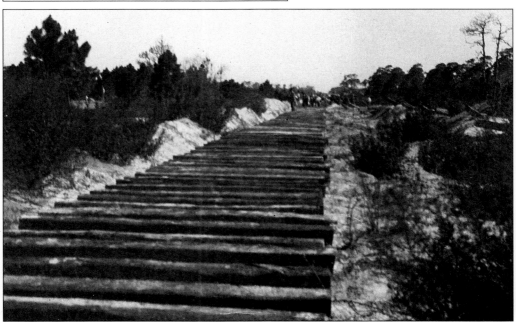

Dense tropical undergrowth and primitive conditions made progress laying the tracks for the railroad slow. Ties were laid directly on sand. The coming of the Florida East Coast (FEC) Railway created famous resorts such as St. Augustine, Palm Beach, and Miami from sparsely settled frontier lands.

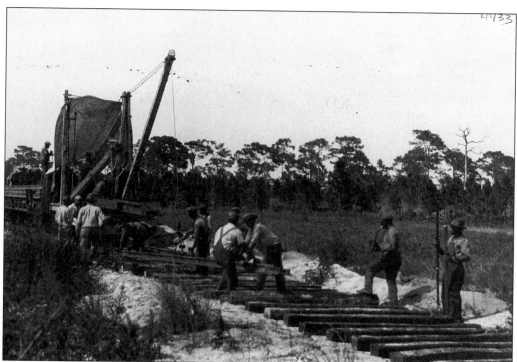

Before the FEC Railway came, travelers to Lake Worth came by steamboat to Jupiter, then boarded an 8-mile-long rail line established in 1888 to Juno at the head of the lake. Boats were then secured to various locations on the lake. The rail line was called the Celestial Railway, as its stations' names were Jupiter, Mars, Venus, and Juno. Until 1899 Juno was the thriving Dade County seat.

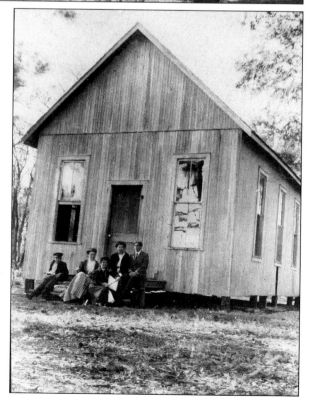

In 1886 the first schoolhouse in the county opened in Palm Beach with eight students. The one-room building was 22 x 40 feet and had no desks. Students sat at tables and used books borrowed from area homes. The building doubled as a church, and worship services were conducted on Sundays.

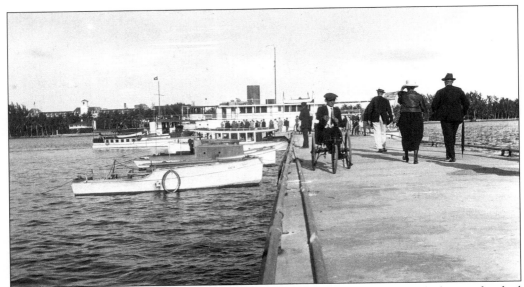

The FEC and Flagler's hotel pioneered in advancing the area long before individual communities such as West Palm Beach, Miami, and Lake Worth were large enough to publicize themselves. Shown here is the West Palm Beach Dock on Lake Worth. In the distance is Flagler's Royal Poinciana Hotel. The hotel opened in 1894; shortly thereafter, the railway arrived at West Palm Beach. The hotel had 7 miles of corridors and was the largest wooden structure in the world.

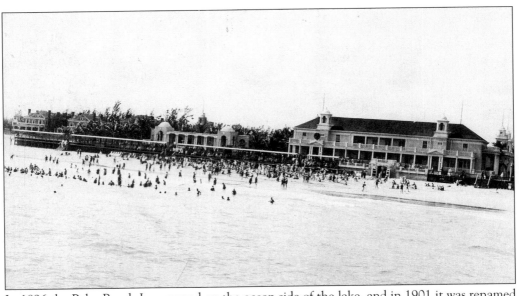

In 1896 the Palm Beach Inn opened on the ocean side of the lake, and in 1901 it was renamed The Breakers. It had the only ocean-front rooms south of Daytona Beach and the first 18-hole golf course in Florida. It burned down in 1903, and a much grander Breakers was built and opened in 1904. Flagler never allowed the word "hotel" to be used in connection with The Breakers.

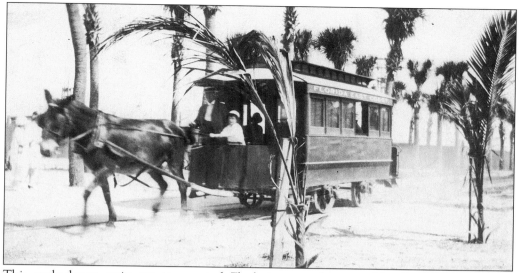

This mule-drawn train car transported Flagler's guests between The Breakers and Royal Poinciana Hotel. It also delivered them to the ferryboat that traveled to downtown West Palm Beach. Shown here driving the car is Vincent Astor IV.

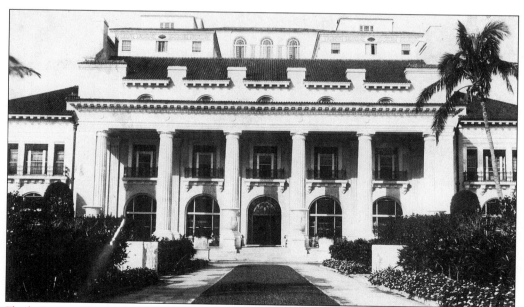

Flagler's magnificent marble "Whitehall" in Palm Beach was completed in 1902 at a cost of $2.5 million. The 55-room mansion was nicknamed the "Taj Mahal of North America." Another $1.5 million was spent on furnishings, including art treasures from around the world. Its Marble Hall is 110 feet long and 40 feet wide and paneled in seven shades of Italian marble.

Flagler forbade any horse-drawn or motordriven vehicles in Palm Beach. This young lady is being driven about the Royal Poinciana Hotel grounds, perhaps for afternoon tea, in what was referred to as a "wheel chair"—or more commonly, an "afromobile."

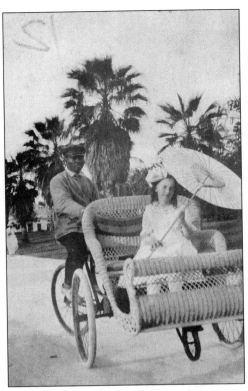

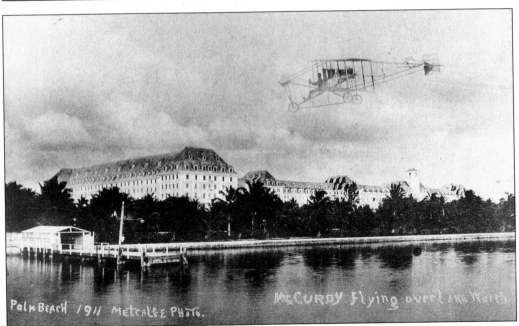

Palm Beachers got an eyeful when James A. McCurdy, test pilot for Curtiss Aircraft, flew a box kite-like flying machine over Lake Worth in 1911. The Royal Poinciana Hotel is in the background. The first commercial air flights in the world began in Florida in 1914.

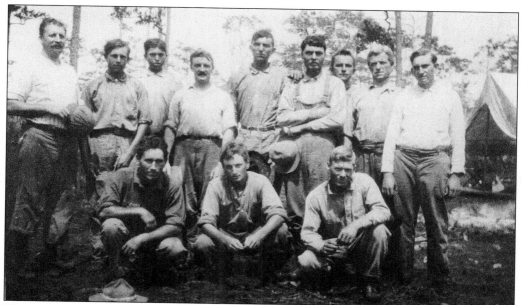

The first survey team in Lucerne, later renamed Lake Worth, began work January 12, 1912. The survey was completed August 1, 1912. Forty-nine thousand acres had been divided into 7,000 tracts of 5 acres or more of farmland and 7,000 townsite lots. Fifty-five miles of streets had been platted. Palm Beach Farms Company provided 3,500 acres for roads, dikes, and ditches.

The earliest settlers lived in the crudest of shelters until homes were built. One newcomer observed the following: "There were no streets or sidewalks on which to go places and no places to go. Less than a year old, the village was little more than a half dozen clearings through the trees to show where the town was to be."

Although the conditions were primitive, the pioneers made the best of difficult early days. Many lived in tents, planted gardens, hunted, raised chickens, and lived off the land. Running water and electricity were still two years away. By the end of 1912 the seven-month-old town had 308 permanent residents, 77 buildings, 876 chickens, 15 horses and cows, 10 wagons, and 36 bicycles.

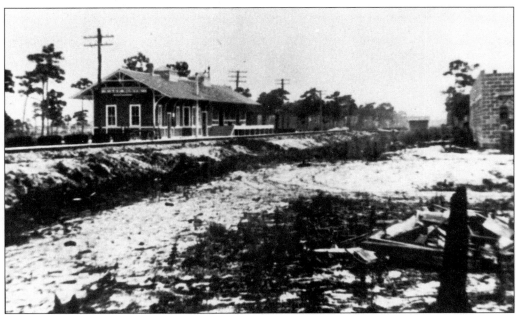

Lake Worth's first railroad depot was built in 1912 and included waiting rooms, telegraph, and freight office. FEC Railway had negotiated with Palm Beach Farms Company during the platting of streets for a block for the depot. A.H. Stimson was the first Lake Worth agent. Weeds, palmettos, and scrub decorated the area south of Lake Avenue where the depot was located.

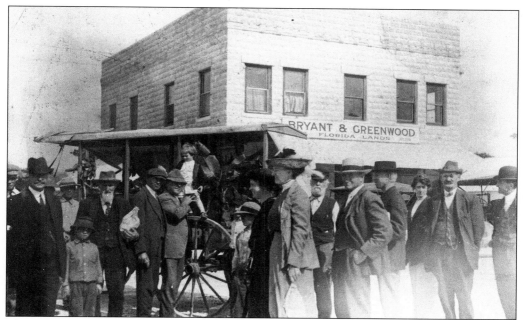

The Palm Beach Farms Company hired the Chicago team of Harold J. Bryant and William F. Greenwood to market their holdings. A large percentage of the earliest arrivals were from the Midwest; however, their nationwide advertising campaign enticed pioneers and adventurers from around the country and Canada. Some of Bryant & Greenwood's earliest literature boasted that "Lake Worth is the only city in Florida without negroes. There are none there. No property is sold to colored people."

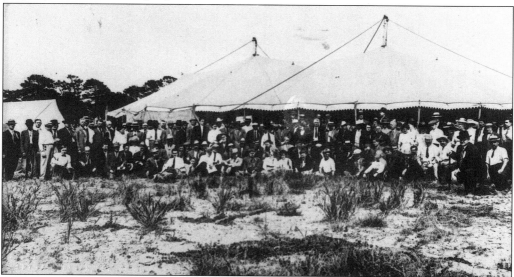

In West Palm Beach in 1912, near Okeechobee Boulevard, Bryant & Greenwood land purchasers or their agents gathered for the drawing to determine the location of their purchase. For $250 one could purchase a "contract," which consisted of one tract of farmland not less than 5 acres and up to 40 depending on the land's desirability, and one townsite on Lake Worth.

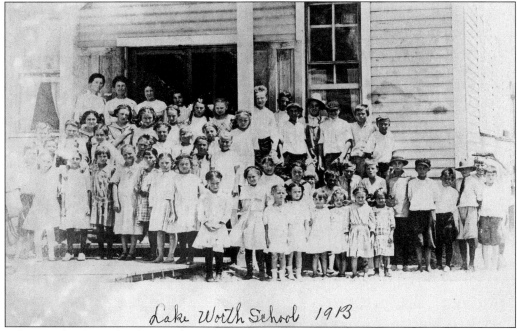

Lake Worth School 1913

Lake Worth's first school opened in October 1912. The one-room wooden schoolhouse was 24 by 36 feet and painted a bright "Flagler yellow." The Royal Poinciana Hotel in Palm Beach was bright yellow with white trim, and it was fashionable to emulate his color scheme. Miss Amanda Snyder, the first schoolteacher, is shown here with her pupils. The school was built entirely with volunteer labor.

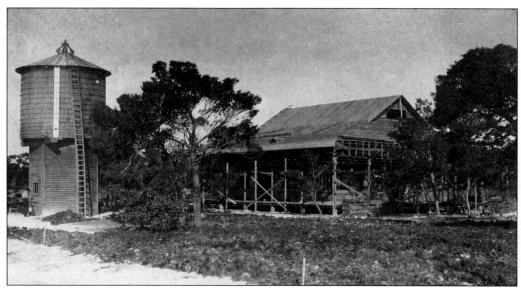

The future Clubhouse and water tower is shown here under construction. An early visitor wrote home about the building, "Clubhouse looks like a barn this way, but it is sure going to be nice when finished." Landscaping would later be added, and bougain-villea-covered arches would be placed at the Lake along with Lucerne corners with benches for resting and socializing.

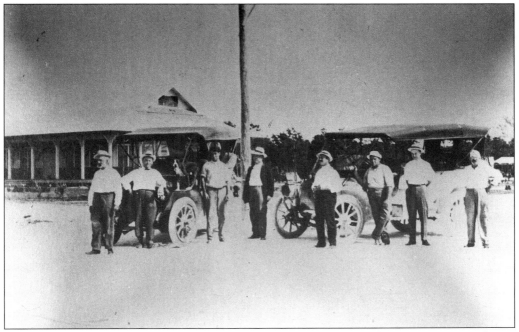

The Palm Beach Farms Company staff is pictured on "I" Street, now known as Dixie Highway, at Lake Avenue in front of the Clubhouse. It was the center of social, religious, and business meetings. Built in 1913, all labor was donated by local volunteers. Palm Beach Farms Company donated the land for the Clubhouse, which would later be renamed the Lake Worth Auditorium. The block it was built on was referred to as Pioneer Park.

The Poinsettia Hotel on Lake Avenue across from Pioneer Park was the first hotel in Lake Worth. Herman Kauz built it in late 1912. To its left is Lyman's Grocery, owned by I.D. Waltz and M.B. Lyman of Lantana. I.D. Waltz brought the first automobile to Lake Worth.

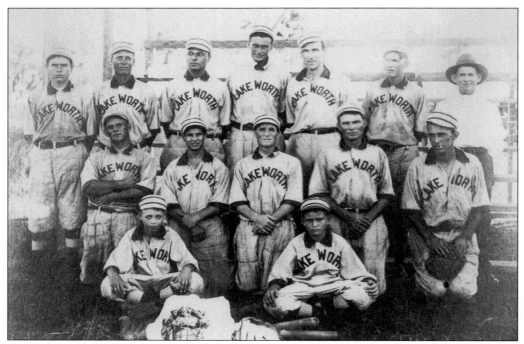

The Lake Worth Skeeters were the first baseball team in Lake Worth. Baseball was a very popular pastime with early residents. The Skeeters were said to be undefeated. Many other activities were enjoyed by residents and their guests. One early Lake settler recollects the following: "Life was hilarious, music and games during the evening, boating, bathing, hunting and beach walking filled each day."

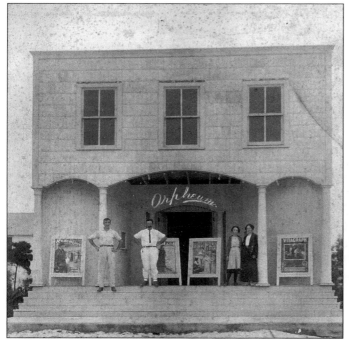

Brophie's Movie was the first "show house," built in 1913 by John Brophy at a cost of $5,000. Lawrence Brophy was its operator, and Mrs. Bertha Ditty was the pianist. It was located on Lake Avenue between "J" and "K" Streets. Its name was later changed to the Orpheum.

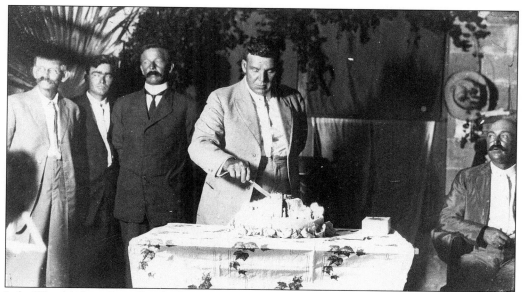

Lake Worth's first post office had opened on August 28, 1912. It was located on Dixie Highway, just south of Lake Avenue. The first day's receipts totaled 46¢. F.H. Billups was the first postmaster and is shown here cutting Lake Worth's first "birthday" cake on May 24, 1913. J.W. Means was appointed the first mayor, K.L. Hifner, town clerk, and Rev. A.H. Shipman, vice-mayor.

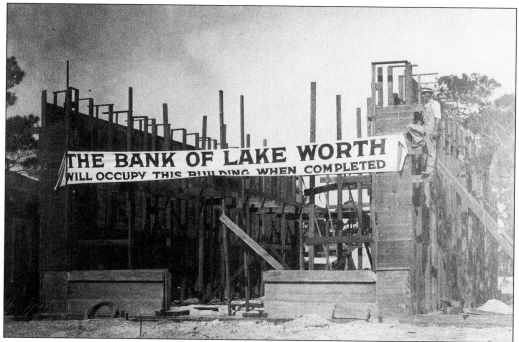

The town's first bank shown here is under construction on Lake Avenue at "J" Street. The contractor and builder was Paul D. Tondu. On opening day, October 13, 1913, the Bank of Lake Worth had $16,018.76 in deposits.

Pioneer Park on Dixie Highway was the site of the first municipal building. At left next to the water tower is the city hall, fire station, two jail cells, and the library. It was built in 1914 at a cost of $4,000. The facility opened June 14, 1915. The Lake Worth Fire Department was made up entirely of volunteers. In October 1913, Herman Kauz, owner of the Poinsettia Hotel, was appointed as the first fire chief. Each volunteer provided his own shovel, rake, and bucket. The

two jail cells remained empty for two years. The town marshall was James O. King. On the right is the Clubhouse. Pergolas and landscaping were designed by Palm Beach Farms Company horticulturist Professor De Gottreau. Behind the Clubhouse was a man-made swimming hole, where "Ole Bob" the alligator lived, as well as a snake pit.

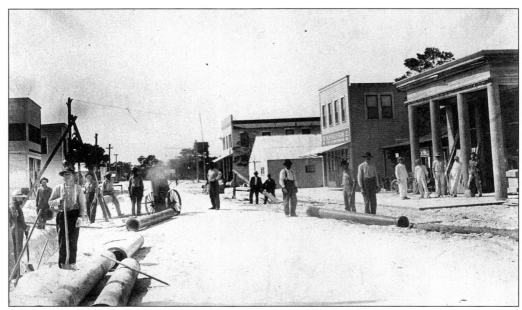

Water mains were laid on Lake Avenue in February 1914. The completed Bank of Lake Worth is at the right with the columns, and the Palm Beach Farms Company offices are next door. On May 18, 1914, the electric current was turned on for the first time. The lights operated from 6 p.m. to midnight. Those residing in the city that day and their descendants are considered Pioneers of the City of Lake Worth.

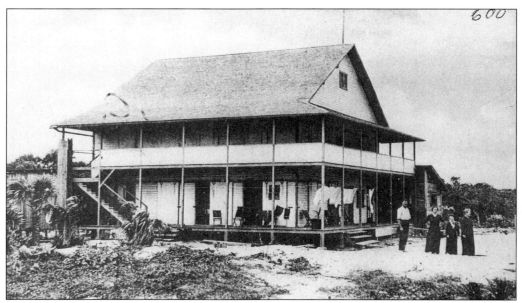

A wooden, two-story, 40-by-40-foot bathhouse was built on the ocean beach, one of Lake Worth's biggest attractions. It had rooms for changing into proper bathing attire, a dining room used for parties, and 50¢ Sunday chicken dinners. Saturday night dances were held upstairs. A path had to be cleared from the lake to the ocean to haul, by hand, 1,700 feet of lumber and 1,700 shingles during construction.

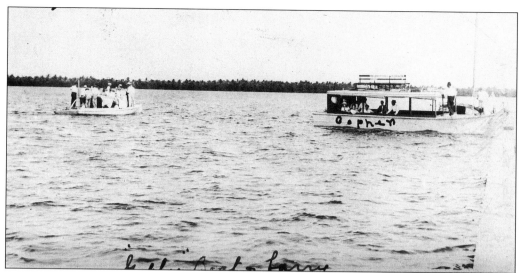

In May 1913, A.A. Jones was given a franchise to operate a ferryboat to transport passengers across Lake Worth, as no bridge had yet been built. Frank Couse later built and operated the *Gopher*. Roundtrip rides to the ocean beach were 5¢. It was powered by a four-cylinder Pierce Arrow engine with dual ignition and was 42 feet long. It could accommodate 40 passengers and made regular trips to West Palm Beach.

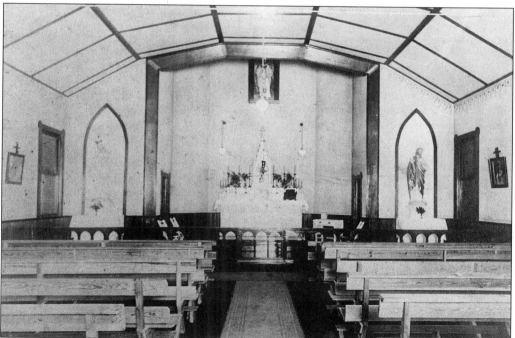

The Sacred Heart Catholic Church was built in 1915 at Fifth Avenue North and Federal Highway. Between 1913 and 1915, Mass was said in various homes on Sundays. The Lake Worth Church was a mission of the Jesuits from St. Ann's in West Palm Beach. Father Bill Nachtrab was the first permanent pastor. Sacred Heart (interior shown here) is the second oldest Catholic church in Palm Beach County.

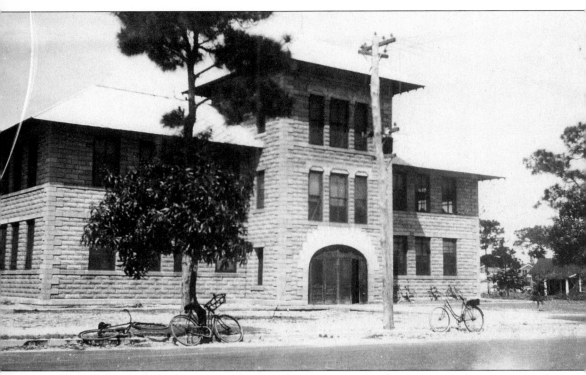

Lake Worth's second school opened September 16, 1915, at Lake Avenue and "M" Street. The building was of cement block construction, 119 feet long, 85 feet wide, with 12 large classrooms, restrooms, teachers' and students' lunchrooms, spacious halls, principal's office, and janitors' rooms. It was designed by G. Sherman Childs, architect of the city hall and fire station. Childs was a member of Addison Mizner's design team and would go on to design many more buildings of note in Lake Worth over the years. Freeholders had voted a $25,000 bond issue for the construction of the school in 1914. Only 13 people were eligible to vote. Eleven votes were cast and nine of them were for the bond issue. A.B. Hoag was the first principal. School hours were from 8 a.m. to 11 a.m. and 12 p.m. to 2 p.m. with 11 a.m. until noon for the lunch hour. Five thousand feet of concrete sidewalk was added April 16, 1916. This school building housed all grades except the twelfth. Seniors attended school in West Palm Beach.

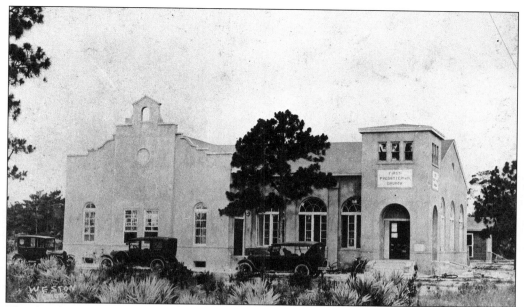

The local Presbyterians held their early Sunday services in the Orpheum Theater, and organized on October 28, 1915. The official dedication of the church was on April 30, 1916. Organizing minister was Rev. J.L. Skerritt. The church was located at Third Avenue North and Federal Highway.

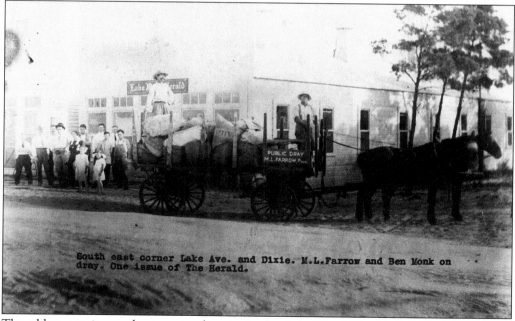

South east corner Lake Ave. and Dixie. M.L.Farrow and Ben Monk on dray. One issue of The Herald.

The oldest continuous business in the city is the *Lake Worth Herald*. Originally called the *Lucerne Herald*, its name was changed when a Lucerne post office could not be obtained from the government, and the town of Lucerne changed its name to Lake Worth. The *Herald* offices were located at the southeast corner of Lake Avenue and Dixie Highway. Here, the Public Dray with M.L. Farrow and Ben Monk prepare to deliver an issue.

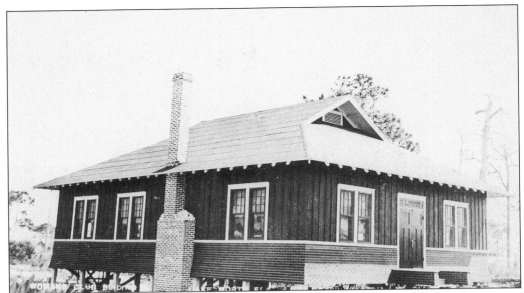

The first Woman's Club was located at South "N" Street, now known as Federal Highway, on a lot donated by Bryant & Greenwood just south of Lake Avenue. Their first "housewarming" took place on December 30, 1915. A public dedication took place in February of 1916. This was the second Woman's Club organized in Palm Beach County.

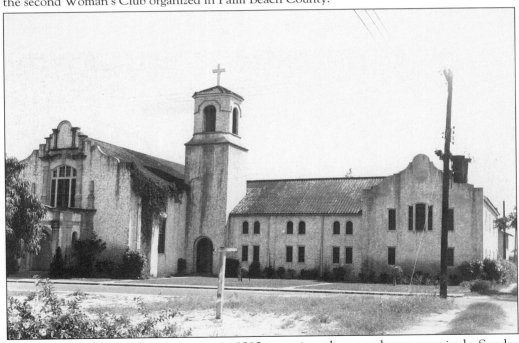

Community Methodists began meeting in 1913 in a private home and soon organized a Sunday school. During the winter of 1913, a parsonage was built on "M" Street on lots donated by Bryant & Greenwood with volunteer labor. Early in 1915, plans were made to build a church, which was finally dedicated March 11, 1917. The furnishings cost $7,000. The church was located on the corner of "O" Street and First Avenue South.

28

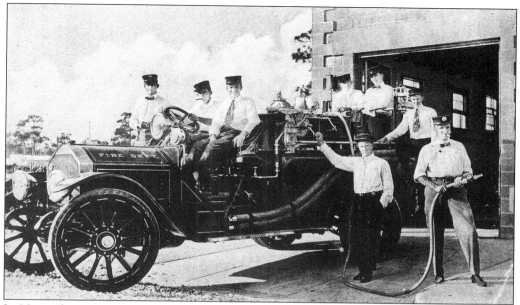

In November, good news was received by R.L. Horsman, phone company manager, at 3:30 a.m.—World War I had ended. The story goes that he called Mayor Alex Drake. The next thing anyone knew was that the firetruck was racing through the streets with H.W. Thurber pointing the way to Vice Mayor McCoy's home to wake him up. When they arrived, he was outside in his nightgown vigorously waving an American flag.

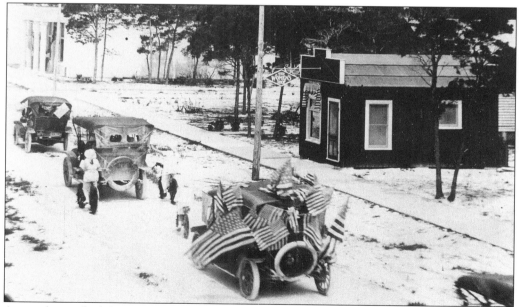

As word spread of the war's end, automobiles began driving up and down the streets, honking their horns. H.M. Stokes walked all over town with a phonograph playing the Star Spangled Banner, waking people up. By 8 a.m. over 100 Lake Worth cars formed a parade to West Palm Beach. Shown here is part of the caravan heading east on Lake Avenue.

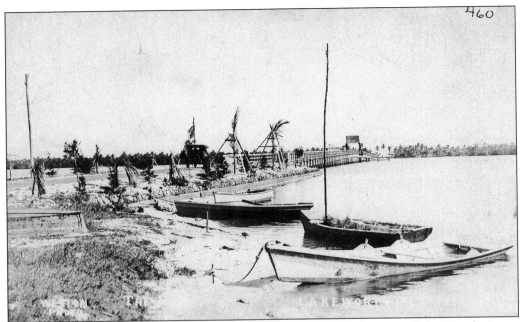

In 1918 construction began on the city of Lake Worth's first bridge across Lake Worth. It was wood on concrete pilings. It was the longest toll-free drawbridge on Florida's east coast. The 3,200-foot-long bridge was opened and dedicated on Independence Day, 1919. Quite a celebration took place in the lakefront park, later to be known as Bryant Park.

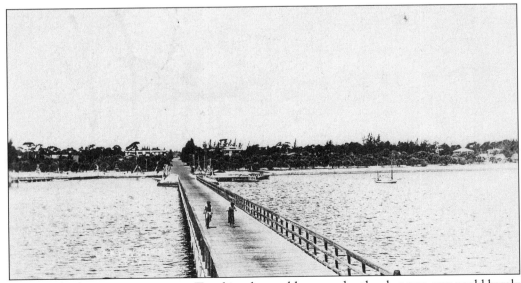

The new bridge was quite narrow. Two bicycles could pass each other but two cars could barely make it. The easy access to the beach more than made up for it. Although the bathhouse had mysteriously burned down the previous year, the beach was still the place to be. Ben Monk was the first bridgetender and lived in a small bungalow on the bridge with his wife.

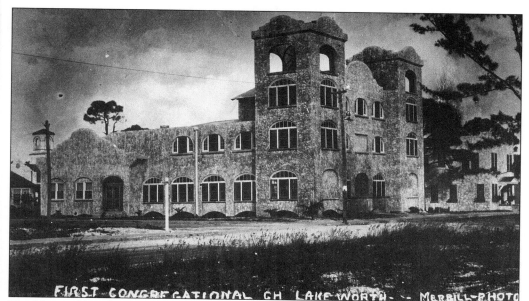

FIRST CONGREGATIONAL CH LAKE WORTH -- MERRILL PHOTO

The Union Church was first organized on November 25, 1912, and met at the school and the Clubhouse. Their new building was dedicated on February 16, 1919, at Second Avenue South and Federal Highway. The first pastor was Rev. A.H. Shipman. They soon became affiliated with the Congregational church.

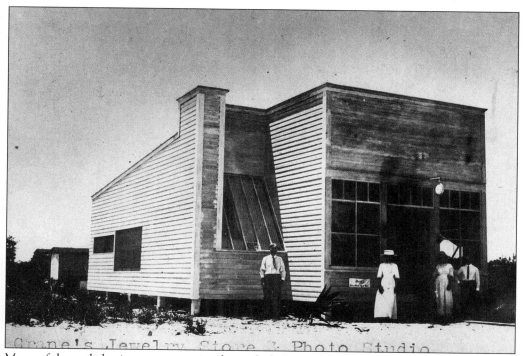

Crane's Jewelry Store & Photo Studio

Many of the early businesses were quite diversified. Crane's Jewelry Store and Photo Studio also sold homemade root beer. While the photo or jewelry business may be slow, one can always use a cold drink. The store was owned and operated by Wade O. and Erma B. Crane.

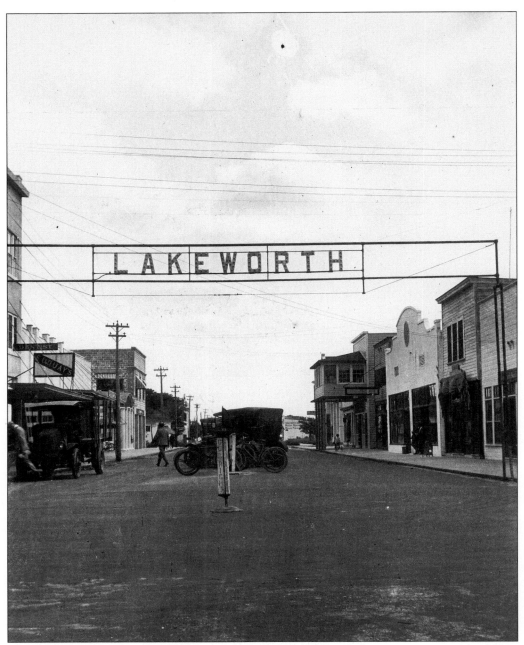

An illuminated sign hung over Lake Avenue at Dixie Highway welcoming visitors in the 1920s. The sign, however, spelled the town name wrong. It was spelled out as one word instead of two. This view of downtown is from Dixie Highway looking east on Lake Avenue. Cars parked at an angle down the center of the street, and traffic was two ways. Soon regulations were drawn up regarding the manner in which cars could be parked, lighted, and turned in town. The speed limit was 18 m.p.h. on Dixie Highway and on Lake Avenue between "H" and "K" Streets; U-turns were strictly forbidden. Lake Worth had 40 miles of paved roads within 2.5 miles, a considerable amount for a town of its size.

Two
"THE WONDER CITY"

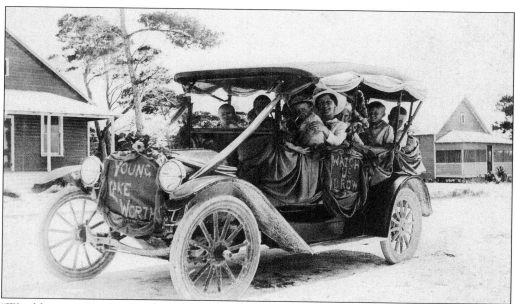

"Would you rather live in the north, in ice and snow or come to Lake Worth and watch us grow." Parades were commonplace in the "boom times" after World War I. Bryant & Greenwood paraded prospective buyers about town. Festivals were held, and July 4 was celebrated. No event was too trivial for a parade in those early days. This car full of smiling revelers boasts a familiar slogan, "Young Lake Worth, Watch Us Grow."

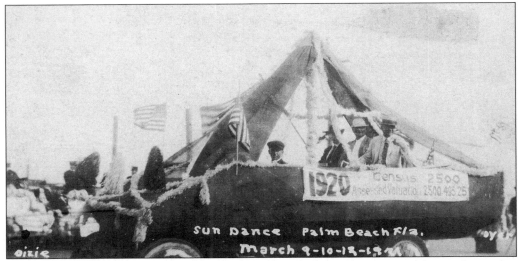

The Seminole Sun Dance was held in West Palm Beach for many years, complete with parades, dances, music, fun, and gaiety. It was held in March to try to prolong the tourist season. At the time, many winter visitors went back up north after Washington's Birthday. The banner on this parade float reads as follows: "1920 census 2500 (in West Palm Beach) Assessed Valuation 2,500,495.25." Lake Worth's population by now is 1,106.

The Fourth of July was yet another event celebrated with parades, picnics, and dances. After World War 1, many began moving around the country seeking their fortunes, and many chose real estate. Wild speculation ushered in the "boom years" of the 1920s. Thousands flocked to the Tampa/St. Petersburg and West Palm Beach/Miami areas. Lake Worth's population would more than quadruple in the next few years.

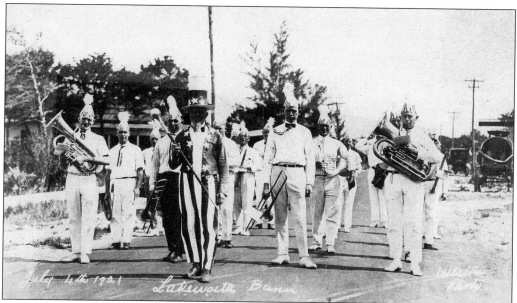

Lake Worth's first band is marching here. Several more would form, and it seemed that one could never have too much music. "Dad" Burbach, dressed as Uncle Sam, leads Henry Cramer's band. Members were John Schuettler, Ernest Koblitz, Harold Widgeons, F.F. Herold, Elmer Farrow, W.J. Sieber, J.K. Reynolds, M. Van Giesen, W.H. Samson, Eppie L. Barber, Richard Bonsteel, and Herman Hernden, the city lifeguard.

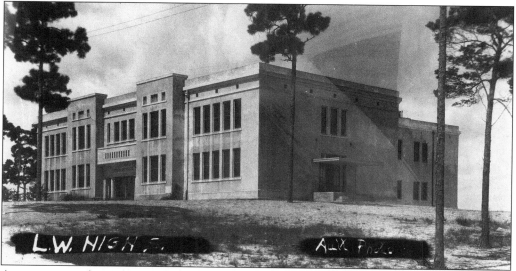

A growing population required the new high school to be built in 1922. It was located "on the hill" at the west end of Lake Avenue, west of "A" Street. J.C. Hanner, of Orlando, built it at a cost of $70,262. Grades one through seven would continue at the current schoolhouse, and grades eight through 12 would be attending at the high school. The building had eight rooms and the largest school auditorium in the state, with a seating capacity of 1,500 persons. A formal opening of the school took place Friday, October 20, 1922. The first graduating class in 1923 consisted of seven girls.

Ground was broken and soundings taken for the concrete foundation for the new Lake Worth Casino and Baths on August 18, 1921. It was located on the ocean, slightly south of the old bathhouse. The contract price agreed upon was $99,500, but costs amounted to $150,000 to erect the Casino and to construct a tunnel under Ocean Boulevard and a 300-foot-long pier out over the ocean.

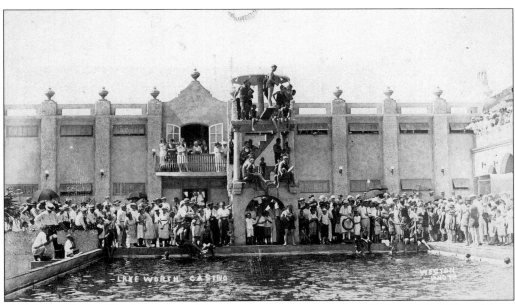

The City of Lake Worth celebrated its tenth anniversary on June 7, 8, and 9, 1922, with an auction sale and joint dedication of the Casino and high school at the Auditorium. The Casino consisted of a saltwater pool with diving towers, shops, restaurants, and a second-story ballroom overlooking the Atlantic Ocean. Gambling was legal at the time, hence, the name Casino.

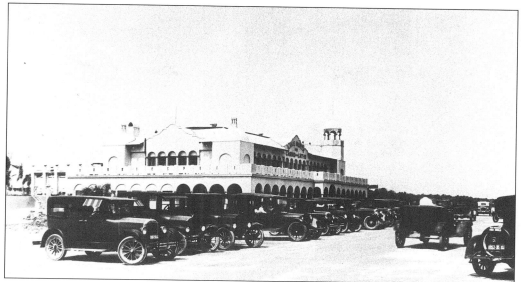

The Casino was immensely popular with people from miles around. Dances, pool parties, and swimming and diving contests flourished. It was described as a "pleasure palace, the like of which is not to be found from Jacksonville to Key West, and while Miami Beach has many more amusing features, her Casino is a mere pygmy in comparison to Lake Worth's bathing and amusement palace." During jellyfish season, fresh water was used to fill the pool.

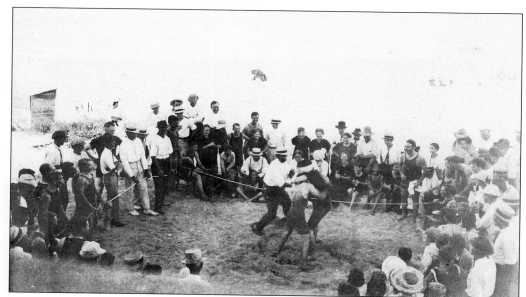

Boxing was another popular diversion of the day. The Carl Vogel American Legion Post sponsored this match on the beach. Matches were put on to raise money for their building fund. Other matches were staged in tents such as one at Lucerne and Dixie with "Battling Kelly" and "Kid" De Vatti.

Pictured here is G. Sherman Childs. Childs was an associate of Addison Mizner, known for designing unique homes in Palm Beach in a blend of Spanish, Moorish, and Italian design. Child's designs reflected this style in many early Lake Worth homes such as the Birthday Cake Castle and the Lakeside Castle. He also designed the first city hall and fire station, Second School, Casino, Masonic Temple, First National Bank, and the second city hall. Childs, along with James Love, the first elected mayor, and L.S. McGill, ventured to Lake Worth in 1912 to build homes for their families in Minnesota. After winters of 25 to 45 degrees below zero, they eagerly invested in Lake Worth acreage. By November their wives and children made the five-day journey to Lake Worth. All three families lived in a single home with rugs hanging as partitions until the others' homes were built shortly thereafter. Soon Mrs. Childs gave birth to Jean, the first girl born in the infant city. Thirteen months later, she gave birth to the first twins, Irvin and Irvene.

Bathing attire of the day included dress-like tops, shorts, and stockings for the ladies. Shown here on the right are Mrs. and Mr. A.J. Burgun of Pittsburgh. Burgun was a Universal Film Company cameraman and shot a promotional film of Lake Worth street scenes and crowds at the pool. Anyone who could "put on a bathing suit and get away with it" was asked to come and dive in.

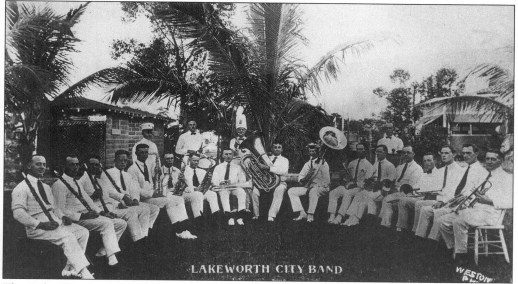

The Lake Worth City Band was formed in 1922. The band was composed of 22 musician residents of the city, many former members of Northern bands of note. Their first concert was at the school campus on the "N" Street (now Federal Highway) side. Ed Eller was the conductor for a 20-week-long series of twice weekly concerts. Town commissioners allotted $6,000 for the series. Each musician received $4.50 per concert.

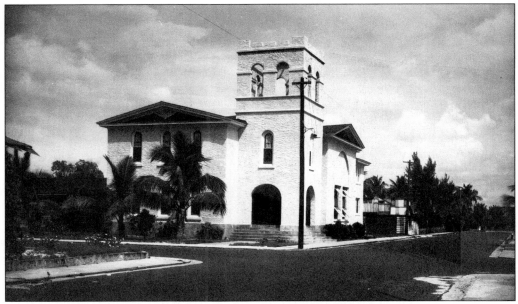

The First Baptist Church was established Sunday, March 28, 1920, with 13 charter members at a meeting at the Woman's Club. Dr. J.M. Walker of Lexington, Kentucky, was the minister at Delray and was the organizing minister. By 1921 the membership had purchased a lot at Second Avenue South and "L" Street for $750. Ground was broken July 20, 1922. The $20,000 building was dedicated March 23, 1924.

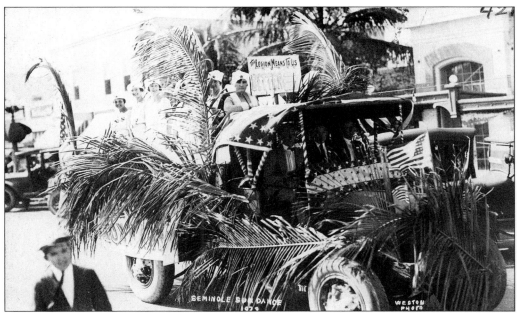

Here is another float in the 1922 Seminole Sun Dance parade in West Palm Beach. This car, covered with palm fronds, was an entry from the American Legion. The girls in the back are dressed in WW I-style nurse's outfits. Promotional events of this sort were held all over the county to stimulate tourism and civic pride in young communities.

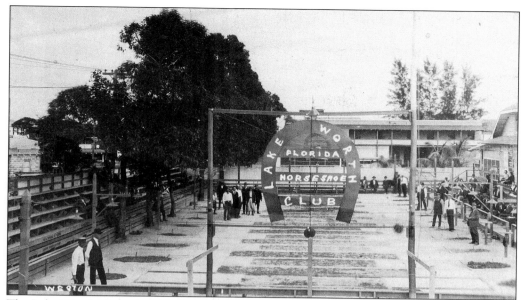

The Lake Worth Horseshoe Pitchers made history in the State of Florida when the state moved to secure headquarters for the National Horseshoe Pitchers Association of the United States. It did this by acquiring a charter that also made it headquarters of other organizations belonging to the State association. This gave the club the opportunity to hold large tournaments in which many of the star horseshoe pitchers could appear.

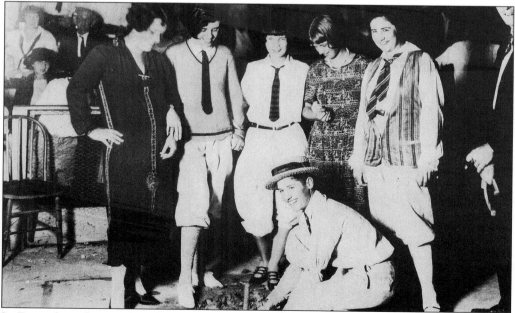

In December of 1923, the Ladies Auxiliary of the Horseshoe Pitchers Club was formed. The club had 500 members by 1924. The horseshoe links were located on the north side of the Clubhouse. Improvements made, including new walks and cement bowls to hold clay and pins, put the Lake Worth links ahead of others locally.

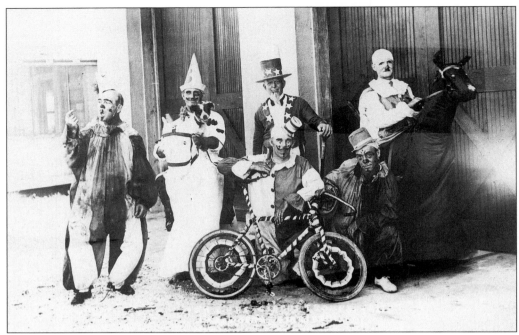

A two-day community circus took place in September, opening with a parade through town starting at the schoolhouse on Lake Avenue. The midway was open until midnight with such attractions as Mme. Pontifax's high-diving pony, a Ben Hur chariot race, and Walter Dyer defying death.

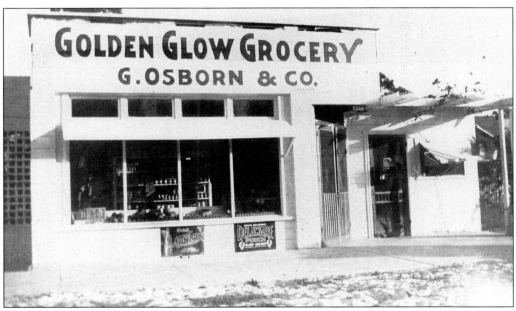

The Golden Glow Grocery was located at 1510 Lake Avenue. The store was owned by Mrs. Golda Osborn. Her son, Guy, worked in the store as a clerk, and her daughter, Miss Beryl C., was a schoolteacher.

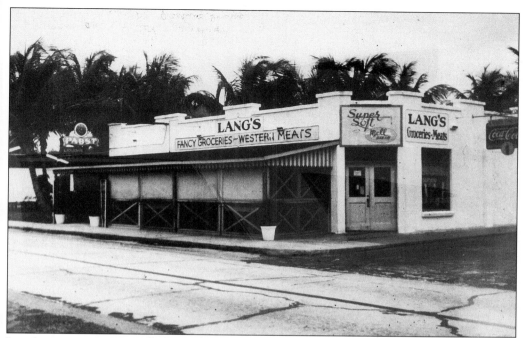

Lang's grocery was originally located at 301 North Dixie Highway. A new store was opened at Second Avenue South and Federal Highway. The store was owned by Joseph E. and Marie Lang and sold general groceries, western meats, produce, and beverages.

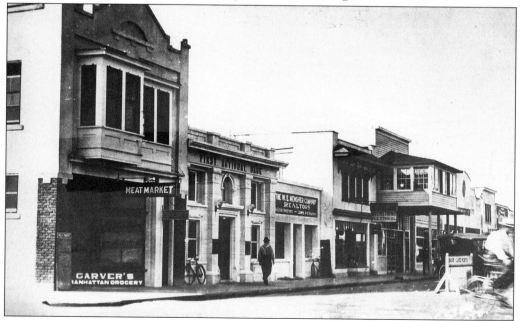

Garver's Manhattan Grocery is shown at the left, located at 801 Lake Avenue. Lee J. Garver was the owner and proprietor. The First National Bank is next door at 803 Lake Avenue, followed by W.E. Menohers Real Estate and Insurance. An electric shop and billiard room are to their north.

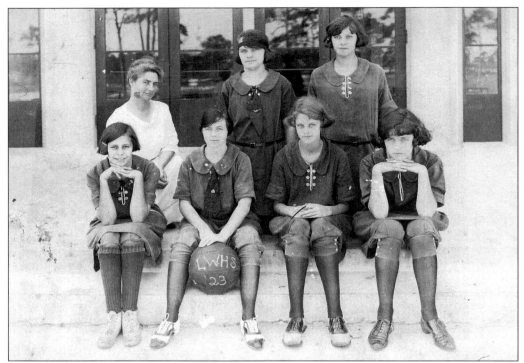

Lake Worth High School's first girls basketball team, the Class of 1923, is pictured here in front of the high school. They are, from left to right, as follows: (front row) Helen Goodman (guard), Captain Marian Deacon (forward), Bernice Hershey (forward), and Victoria Dahlberg (guard); (back row) Miss Washburn (coach), Signie Hagg (side center), and Elizabeth Te Linde (center).

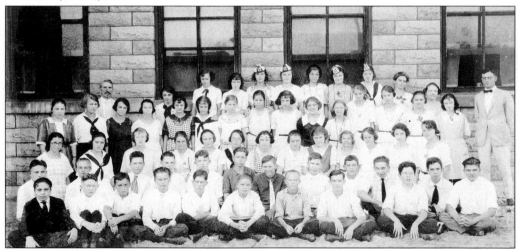

The student body of the Second School, attending the 1921–22 school year, is shown here in front of the school. The seven girls from left to right on the back row are the members of the first graduating class of the new high school. Commencement exercises were held on June 1, 1923. Members were Naomi Shipman, Vera Speck, Lyevia Greene, Eleanor Hotchkiss, Vera Gies, Helen Rhinehardt, and Ethel Heglund.

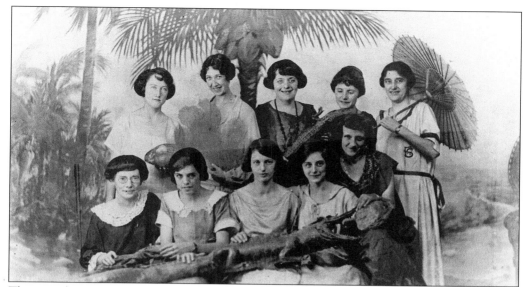

These smiling young ladies are the female teachers for the two Lake Worth schools for the 1923–24 school year. These sorts of studio photos were very popular at the time for the folks "back home." Notice that they are posing in front of a palm forest backdrop, holding a sea fan, coconuts, and stuffed alligators.

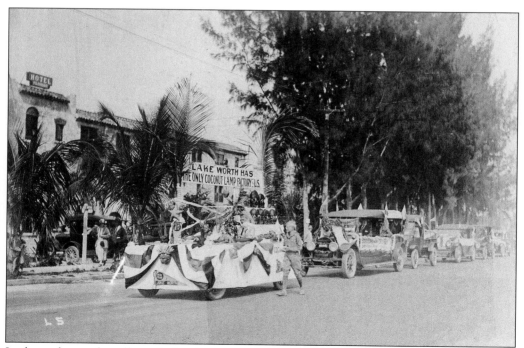

In the early parades, all one had to have to join in the fun was a car, a banner, or ribbons. This float proudly proclaims, "Lake Worth has the only coconut lamp factory in the United States." It was owned by Willard King, son-in-law of founder H.W. Lazette. It was first located at 832 North Dixie Highway, then moved to 13 South "J" Street.

This is probably the reason Lake Worth had the only coconut lamp factory in the United States, maybe the world! Many travelers to Florida probably remember seeing coconut monkey heads, American Indian faces, and other such oddities sold as souvenirs to tourists. Shells, palm bark, and coconuts were combined in what some called "floradana." The factory also kept live gators that frequently got loose and were found strolling on Lake Avenue.

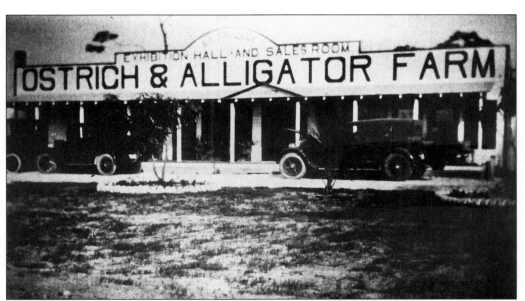

The Ostrich and Alligator farm was owned and operated by Fred W. Anderson. The "farm" originated in Riviera Beach (north of West Palm Beach). It moved to the Lake Worth area. It was listed in various directories of local attractions as being within the city limits of Lake Worth. Actually, it was located in the city limits of Lantana. Admission was 25¢.

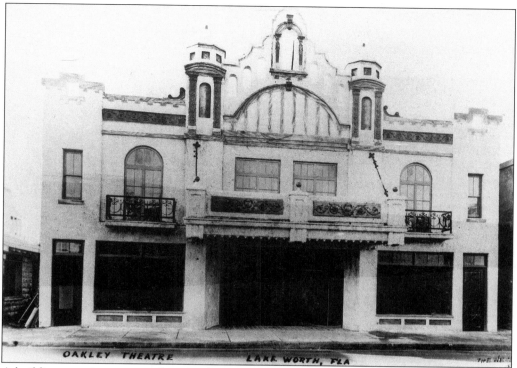

A building permit was secured in April of 1924 for the Oakley Theater. Costs were expected to be $46,000, but like today, cost estimates are subject to change. When the theater opened in November, the total had risen to $110,000. Brothers Clarence E. and Lucien E. Oakley went into the grocery business to help finance their dream. Financial reverses were said to be behind Lucien's suicide, and many are convinced his ghost still inhabits the theater.

West Grade School was built in 1924 to accommodate Lake Worth's growing population. It was located adjacent to the high school at the corner of "A" Street and Lake Worth Road. Initial enrollment for the 1923–24 season doubled from October 1923 to January 1924. Some students at the Second School had been attending the Hypoluxo School, and some classes had been held in the attic.

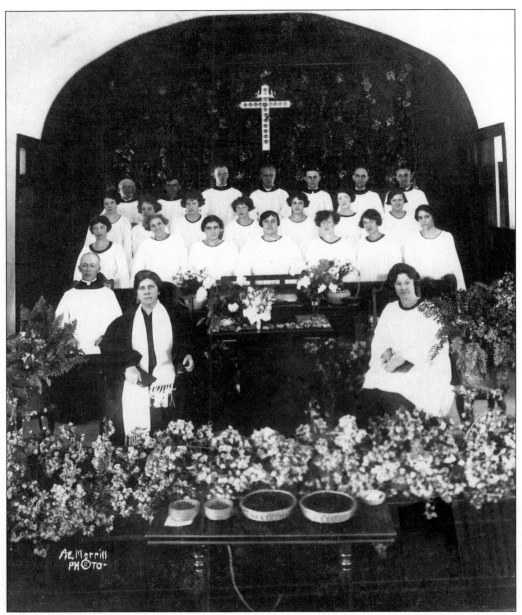

Lillian Britton Fulton, at left holding a Bible, became the minister of the Congregational Church, originally the Union Church. She was the first woman ordained into the ministry of any faith in the state of Florida. For years she had traveled as a lecturer and appeared on the same platform as Billy Sunday. During her ministry, the church frequently overflowed the aisles into the street. She was the first woman in the United States to receive the degree of Doctor of Divinity.

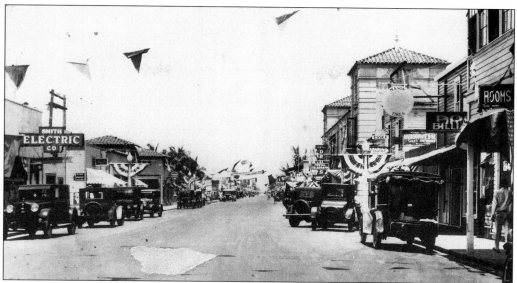

This is Lake Avenue looking east toward the ocean, *c.* 1925. Business is booming, and new arrivals are commonplace all over Florida. At left is Frederick H. Smith Electric Company at 802 Lake Avenue. Across the street is a typical rooming house, and at 809 is a billiard parlor. Real estate offices are abundant all over town.

Lake Worth's second fire station was built in 1925 at 1020 Lucerne Avenue, complete with a brand new siren. Previously, the department was called out by clanging on the old bell at city hall. The second floor of the building was used by the police department for two jail cells.

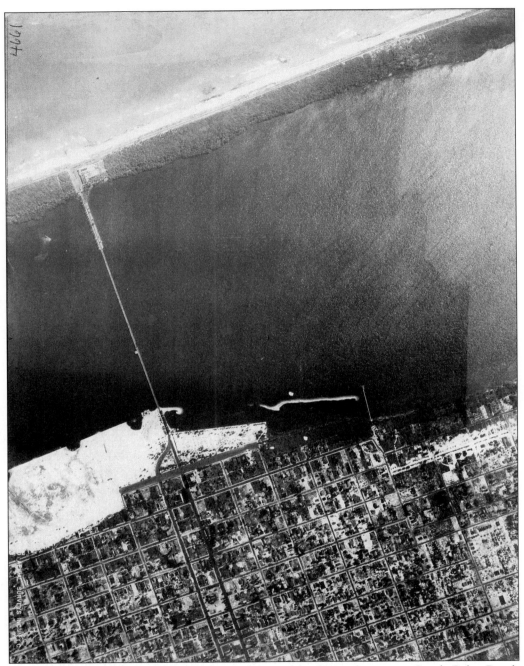

This rare aerial photo, *c.* 1925, shows the strip of land now known as South Palm Beach (otherwise known as "condo land"). Along the water's edge, Ocean Boulevard is visible leading north to the Casino and Baths. Over the bridge, the Gulfstream Hotel had just been completed. The light sandy area at left is where the Municipal Golf Course would soon be constructed.

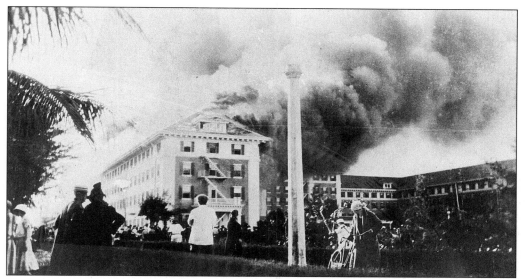

Flagler's ocean-front wood Breakers burned to the ground March 18, 1925. Reportedly, the cause of the fire was the curling iron of Chicago mayor "Big Bill" Thompson's wife. Among those escaping the blaze were Marjorie Merriweather Post and the "Unsinkable Molly Brown," who had survived the *Titanic* sinking in 1912. The fire burned for two days despite volunteer efforts from Lake Worth and as far south as Miami.

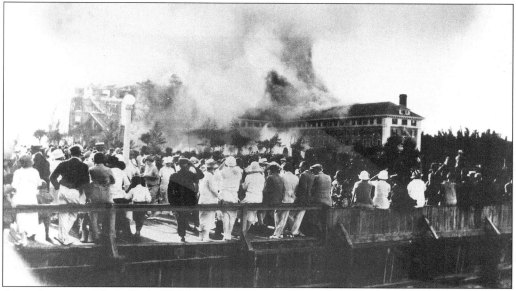

According to resident Jean Childs, "Fire broke out in the afternoon and burned all night. Everybody went down to the Lake Worth Bridge to watch. Fire trucks came up from Miami to help control the blaze." Flagler's heirs built yet another Breakers in 11 months at a cost of $6 million, inspired by the Villa Medici in Rome. The current Breakers opened December 29, 1926. Flagler's heirs declared it the "acme of perfection in design and magnificence."

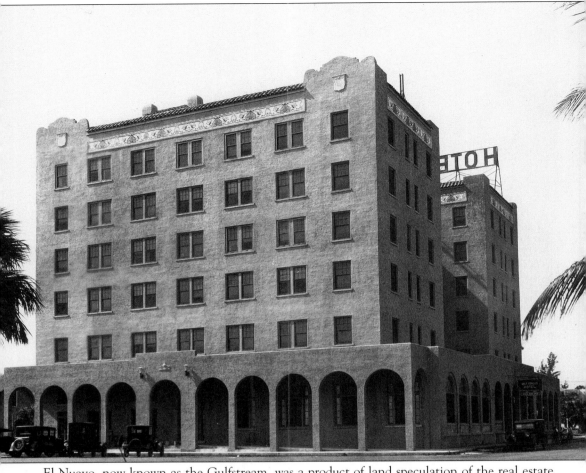

El Nuevo, now known as the Gulfstream, was a product of land speculation of the real estate boom. People were flocking into the area, and there were insufficient hotel rooms. The group behind the venture consisted of G.H. Glover, a field correspondent of Forest & Stream of New York; Dr. William Nutter of Lake Worth; and Frank Heywood, a manufacturer from Minneapolis. Both local banks got behind the project as well as local stockholders. All had great expectations. Six stories high with 135 rooms, the hotel is visible when one approaches from across Lake Worth. Original plans called for a sixth-floor restaurant and roof garden for sun bathing. The building permit taken out on the original design in 1923 was for $225,000, the biggest in Lake Worth history. Work soon halted due to financial constraints. By March of 1924, after a modified design had been submitted by G. Lloyd Preacher & Company, work was resumed. By June it was renamed the Gulfstream Hotel. Formal opening ceremonies and dedication took place on January 25, 1925. The Gulfstream eventually cost in excess of $600,000.

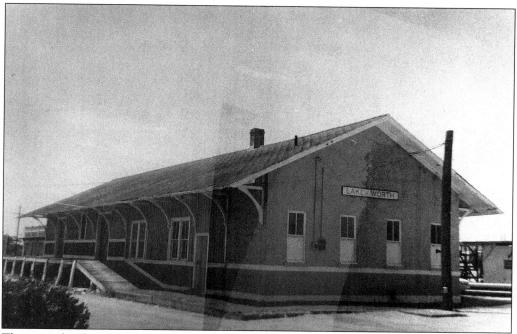

The second railroad depot was built to accommodate the increasing amount of passengers and freight. An extensive expansion program was instituted to meet the demands of the day. This included laying a second track between Jacksonville and Miami, rebuilding many bridges, shops, and office buildings, as well as improving freight and terminal facilities. When the bottom dropped out of the real estate market, the railway was forced into receivership.

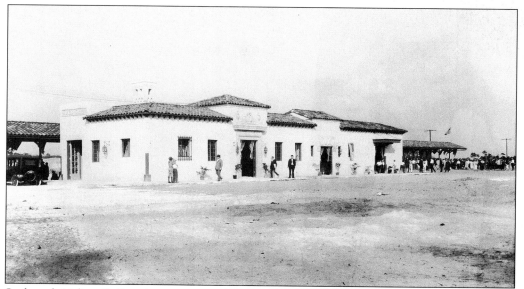

Seaboard Airline Railroad passenger and freight depot is shown here at 1730 Fourth Avenue North. L.L. Lamar was the railroad agent. In 1926 the railroad extended a branch from Wildwood to West Palm Beach, then continuing south to Miami. The first freight train arrived in December of 1926.

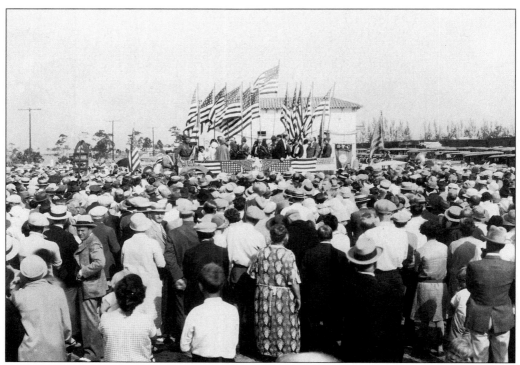

On January 8, 1926, the *Orange Blossom Special* arrived amidst great fanfare. S. Davies Warfield, president of the Seaboard Airline, traveled back and forth with the train, greeting the waving crowds as bands played. Pretty girls gave out orange blossom corsages to the ladies and tie tacks to the gentlemen. Events like this brought out the whole town.

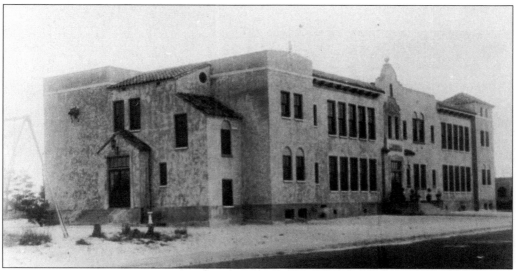

Increasing numbers of students caused crowded conditions at all of the city's schools and made it necessary to build two new grade schools to accommodate the students. North and South Grade Elementary Schools were built in 1926. The City purchased the Second School building to use as a city hall. By September over 2,000 students were enrolled in the city schools.

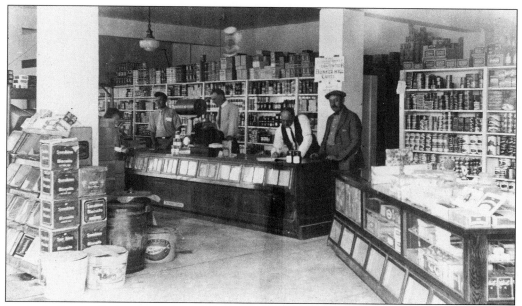

Jarvis & Boutwell was located at 132136 South Dixie Highway and was owned by W.A. Boutwell, president; J.J. Jacob, vice-president; and Walter A. Boutwell, secretary. The store sold fancy and staple groceries, western meats, fresh fruits, and vegetables. The senior Boutwell, W. Arthur, also served as vice-mayor and was on the school board.

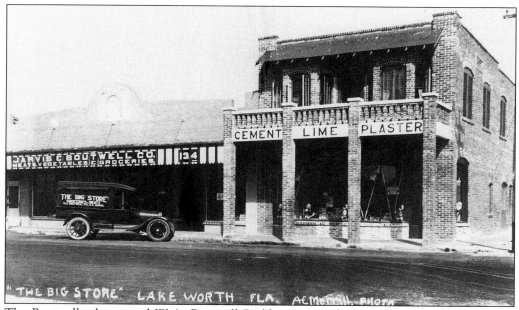

The Boutwells also owned W.A. Boutwell Building Materials, located on South "H" Street. The 136 South Dixie location also served as the residence of the junior Boutwell. W.A. Boutwell Sr. was very much involved in the early development of Lake Worth, including education. He also owned Boutwell Dairy, invented Half & Half, and pioneered in raising the quality of cattle and milk processing in Florida.

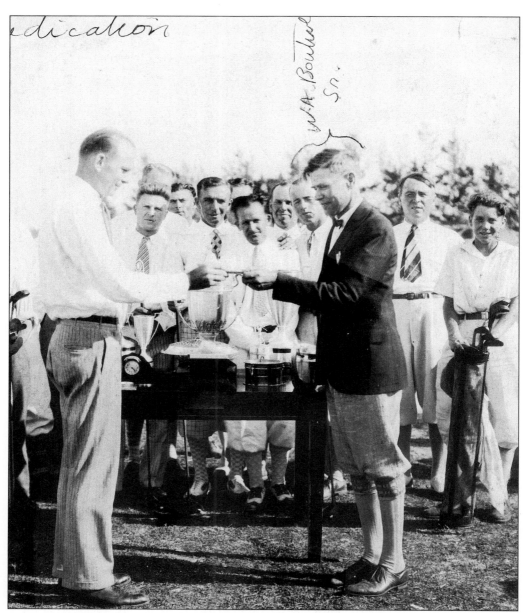

W.A. Boutwell Sr. came to Lake Worth in 1920 from Boston and immediately became involved in civic affairs. He proposed that 105 acres of lakefront property be utilized as a municipal golf course. This property had been given to the City by Palm Beach Farms Company with the stipulation that it be used for public purposes. Shallow parts of the lake were dredged and became fill, and a seawall was built. The formal dedication was on November 16, 1926. W.A. Boutwell (in knickers) is pictured.

A bond issue had been secured in 1925 for $385,000 for the money needed to build the course. Ivan Mann, city engineer, designed and engineered the building of the seawall, and an unknown "Scotchman" from Miami designed the course for $12,000. Shown above is the first Clubhouse, built between the 14 green and 15 tee at Lake Avenue near the bridge. It was built in 1926 by E.J. Brodbeck & Sons for $2,127. It was enlarged and painted in 1927 for $375.

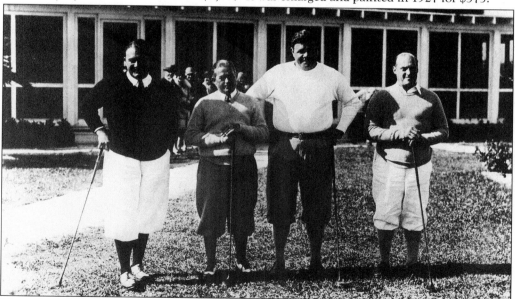

These four gentlemen enjoyed a round in the early days of the golf course, which gained popularity yearly. Cameron Trent was the first golf pro. The daily greens fee was 75¢ for residents and $1 for nonresidents. Children played for 20¢. A summer membership could be obtained for $15. Although three of the four are unidentified, no one can mistake the smile or physique of the third gentleman, Mr. Babe Ruth.

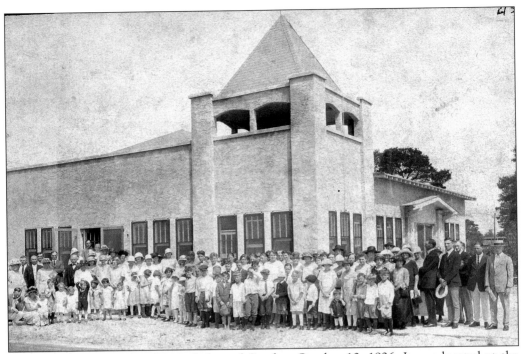

The First Christian Church was dedicated Sunday, October 10, 1926. It was located at the corner of Third Avenue North and "J" Street. The church had begun years earlier, in 1917, when 14 people organized at a meeting in the home of Mr. and Mrs. Stirman. Later the group met at the Clubhouse (formerly the Auditorium). The group also met at the ocean beach for services and baptisms.

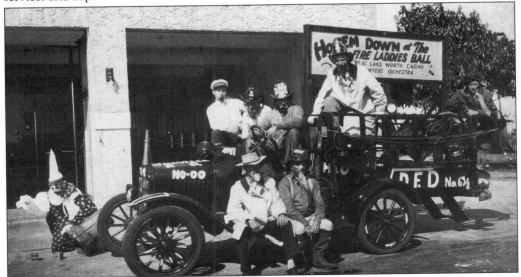

For a number of years, the Lake Worth Fire Department had a masquerade ball as a fund-raiser. The "Hoedown at the Fire Laddies Ball" was held in the town Auditorium, and fun was had by all. Dancing, bands, clowns, and costumes was enjoyed; however, no alcohol was consumed, legally anyway. Prohibition had been in force since 1920.

Three
BLACK SUNDAY

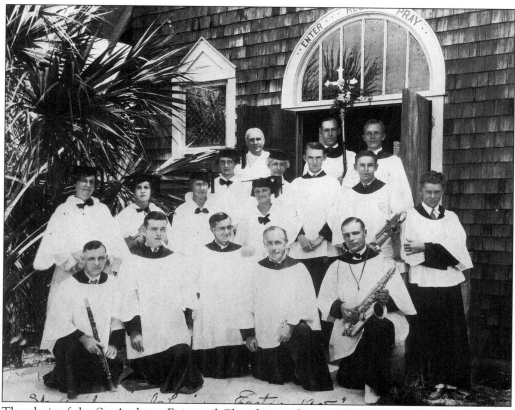

The choir of the St. Andrews Episcopal Church was photographed in front of their church at Lucerne and South Palmway on Easter Sunday, 1928. The church is the oldest in its original location in the city. Rev. G.A. Ottman of West Palm Beach organized the group in 1914. They began meeting in a private home and met later at the city auditorium. Plans were underway at this time to build a new church. Very soon, this would become a necessity.

Earl J. Reed Eugene J. Bunker
J. H. Harwell Frederick J. Bryant
McDowell Ana Bunker Herbie Evans Herold Emerine. Robert E. C

The banking industry was suffering as a result of the Land Boom gone sour. First National Bank employees are shown here. On March 14, 1927, however, the bank closed their doors forever. In April the First Bank and Trust Company of Lake Worth also closed. Ocean City Bank in Delray Beach did not open the following Monday. Citizens' Bank in West Palm Beach finally closed June 22, 1928, along with Kelsey City State Bank and First American Bank.

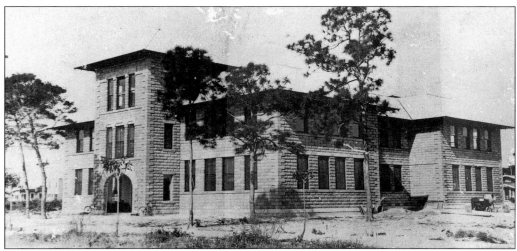

The Second School remained a school until the end of the 1927–28 school term. In June of 1928, work began to remodel the building into the municipal building to be city hall. By late July, all city administrative offices had moved into the building that included governmental offices and commission chambers.

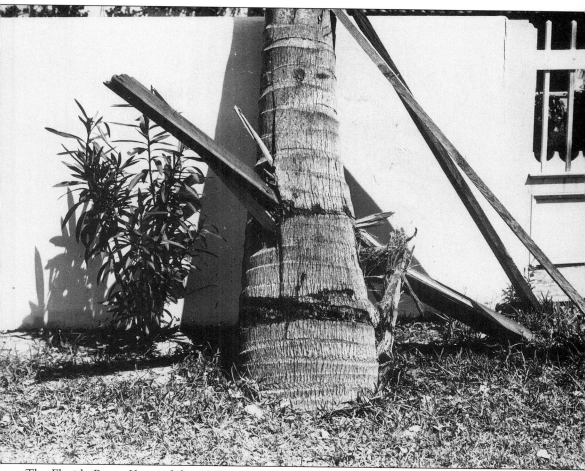

The Florida Boom Years of the 1920s were not to last forever. Rabid speculation in lands and acreage brought investors by the thousands. Swampland was bought and sold without regard to its being underwater. Real estate offices all over the country sold property sight unseen. Each buyer had dreams of becoming rich overnight, and many did, but only on paper. Before it was all over, there was no market left, and many were wiped out, long before the 1929 Crash. Unfortunately, the worst was yet to come in Lake Worth. September 16, 1928, was to become the day that the Palm Beach Hurricane devastated South Florida. Many either ignored warnings or were unaware. Weather reports were vague, and some even predicted the storm would be minor. The storm killed 1,000 people on its way through the Caribbean. Reports said that winds reached 150 m.p.h. or higher. By noon Sunday, heavy seas and high tides threatened the bridge, and all traffic to the ocean was halted. The skies darkened, and wind reached hurricane strength. The magnitude of this storm is evident from this photograph of a 2 by 4 board driven through a palm tree.

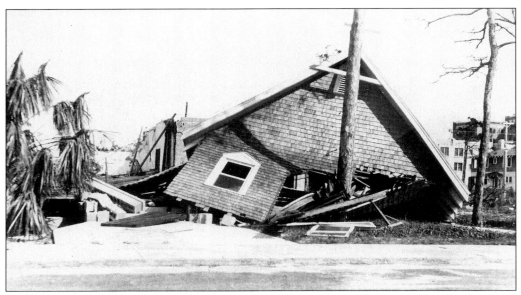

G. Sherman Childs and Mayor James Love built St. Andrews Episcopal Church, the city's earliest church. Some hardy church members tried to attend services the Sunday of the hurricane and were sent home. Five showed up for the 11 a.m. morning prayer. It was the last service ever to be held in the little church. The last entry made in the log was simply "Church destroyed."

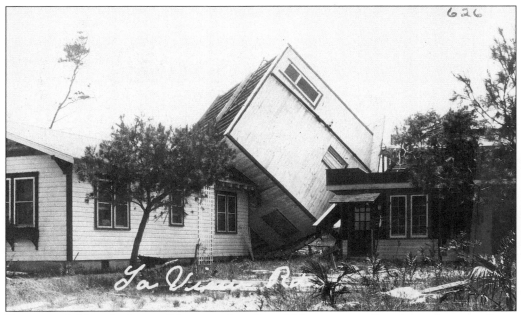

Fierce winds blew for hours. "Corrugated roofs could be seen scuttling down the street," one person recalled. Another said, "Hell was out and no way to stop it. Description fails, sheets of rain and black flying objects, many traveling too fast to be recognized." Only a handful had ever experienced anything remotely like this storm.

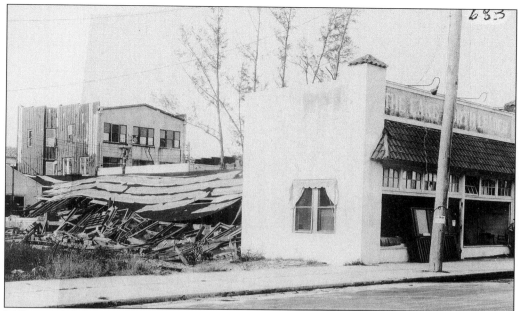

Millions of dollars in property was destroyed. Much loss was due to lack of preparation. Most loss was due to substandard housing that had been hastily constructed in the boom years to house the large influx of residents. According to records, less than ten percent of homes in the city escaped injury. Practically every business or home was left without a roof.

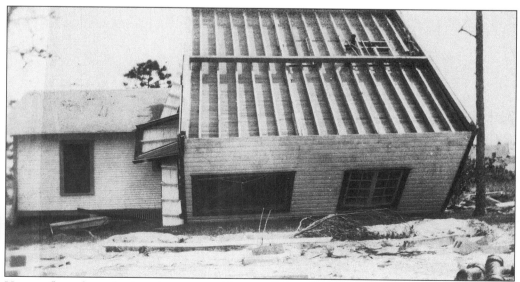

Homes flew through the air or were blown off foundations. This home was torn off its foundation, blown 100 feet, and landed on top of its neighbor. Another family reported hiding under their beds while the storm lifted their home off its foundation; "it was a feeling like a boat floating off a ramp in the water."

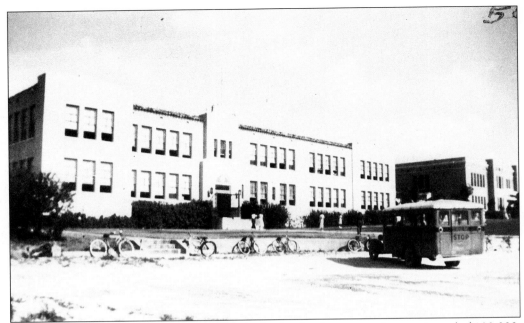

A new junior high school was built next to the high school at a cost of approximately $100,000. The school was dedicated Friday, September 14, 1928. The new building was acclaimed by local school authorities throughout the state as one of the most modern school structures in Florida.

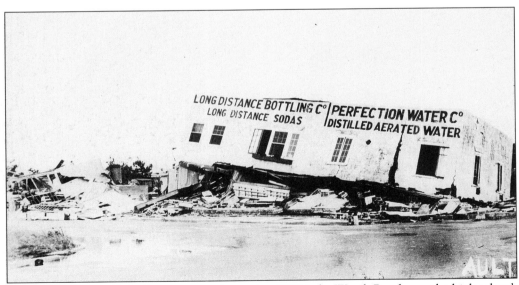

The Long Distance Soda Company was located at 1707 Lake Worth Road near the high school. As can be seen from this photo, it appears to have gone some distance, landing atop other wreckage. Similar sights were everywhere. Pieces of wood and roofs cluttered yards and streets.

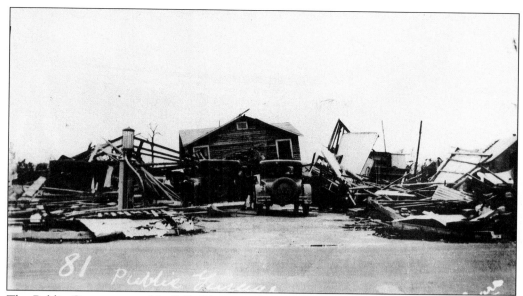

The Public Garage, owned by L.E. Glass, was located at 115 South Dixie Highway. It and its neighboring wooden buildings fell flat. Everywhere, buildings were reduced to masses of tangled wood and steel. Glass, bricks, and concrete light poles were crumpled and broken.

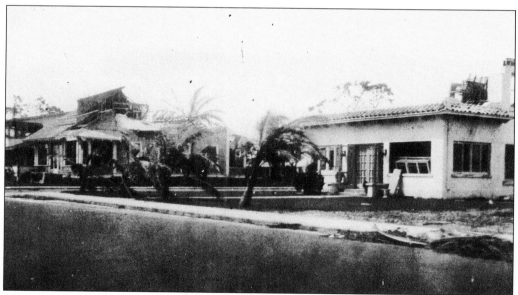

These two homes both lost roofs and second stories. Windows left unshuttered broke at the first gale. Even windows that had been nailed down and boarded up were lost to the raging winds and flying debris. In Pahokee it was reported that, "chunks of muck as large as Fords were blown about by the wind."

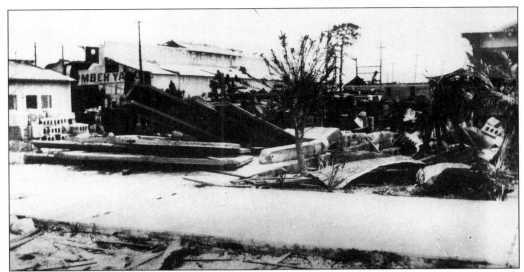

Lumber is about all that is left here at this lumberyard. The storm seriously damaged 1,447 business establishments. Five hundred and fifty-two businesses were totally destroyed. In Lake Worth, 200 businesses were damaged and 50 completely destroyed.

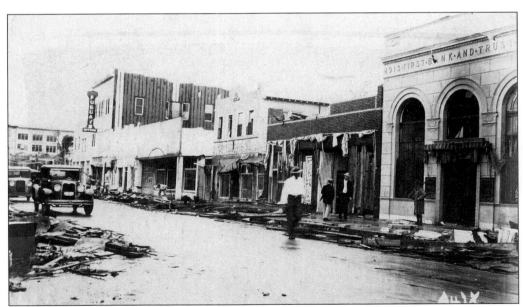

During the lull, or eye of the storm, the sun came out, and dazed residents left their homes to see incredible sights such as trees and lampposts broken in half. Many were not aware that soon the storm would resume with equal or greater fury. Some attempted to drive to check on friends or family and found homes in ruins, crushed like eggshells.

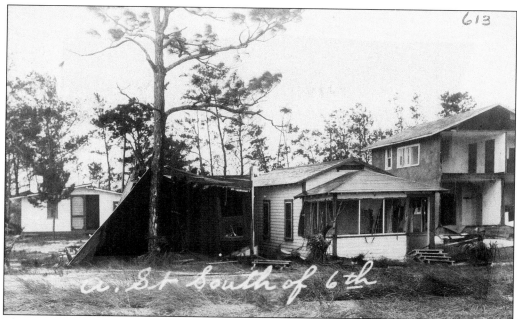

The eye is caused by winds circling a low-pressure area with the center being perfectly calm. The barometric pressure was the lowest ever recorded at the time, nearly low enough to burst eardrums. The lull lasted about an hour, then the winds returned from the south. Paint was stripped from cars, and many homes that survived the first onslaught were tossed like toys.

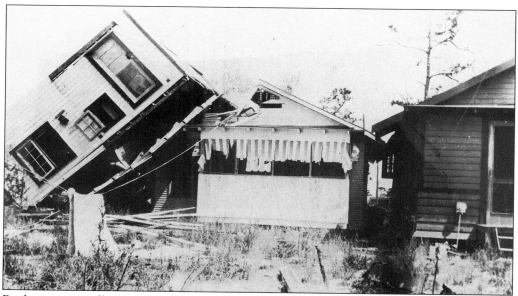

By dawn, it was all over, except the recovery. Heartbreaking accounts abound of families who took shelter elsewhere and came home to find all of their worldly belongings destroyed. Another account described the following: "It was a sight. Here a house facing the quarter; there one on its side; there one flat like matches; here one upside down; there the whole upper story a hundred feet away."

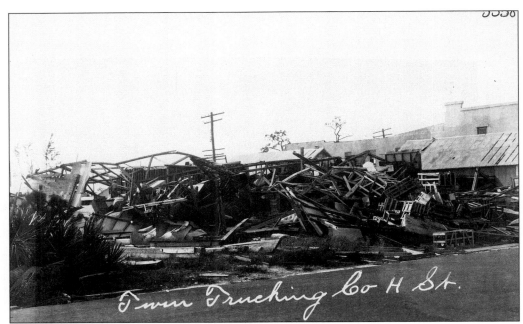

Twin Trucking Co H St.

Amidst all the tragedy, some amusing accounts were told as well. The high school was being used as a shelter, and one person who stayed there related, "There were cripples and babies and dogs and cats and even pet rats. Our cat behaved very nicely, only he did long to jump on some of the dogs and scratch their eyes out." One other quote seemed to sum it all up: "The city looked much as if a giant hand had taken a spoon and stirred."

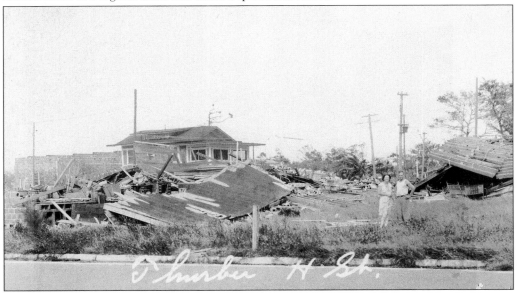

Thurber H St.

Immediately, relief work began. The American Legion began the organization. The Gulfstream Hotel suffered serious damage to their fifth and sixth floor; however, it was utilized as a hospital. Relief stations were also set up at the freight station, junior high school, and North Grade Elementary School. The Christian Science Church set up a soup kitchen in the Boydston Building on "J" Street, and refugees ate there regularly.

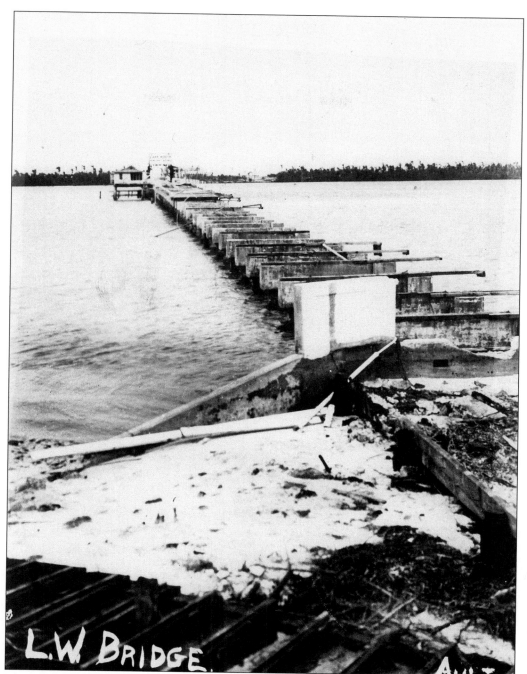

L.W. BRIDGE

The Lake Worth Bridge was severely damaged by the wind and tide. It is said that parts of the bridge wound up in Lantana. It would be some time before repairs could be made. The Casino was damaged as well. Lake Worth police issued an order prohibiting the purchase of second-hand goods without a permit. The north and south entrances to the city were being guarded to prevent looting. It would not be until late December that repairs could be affected and ocean access could be restored.

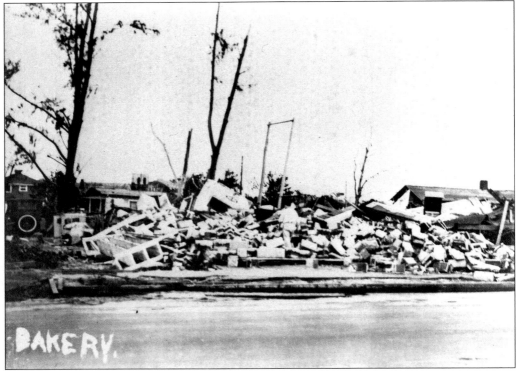

BAKERY.

The American Red Cross set up five emergency relief kitchens and brought 200 cots to the high school. Police, fire, and city officials worked day and night in the efforts. Water service was maintained, and electric power was soon restored in most areas. Practically every street in the city had been blocked with debris and was cleared to expedite recovery.

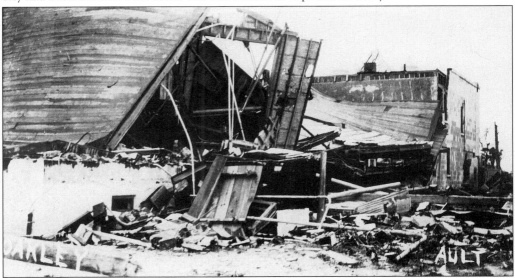

OAKLEY AULT

The Oakley Theater was almost totally destroyed and would eventually be rebuilt at a cost of approximately $50,000. It was still showing silent films and was later equipped for the "new talkies."

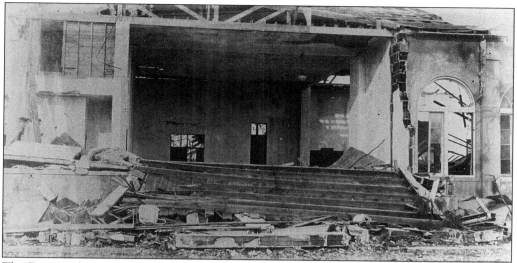

The First Presbyterian Church opened for Sunday services, as usual, on Black Sunday. Strong winds continued, and by 5:30, the church had been "rendered a complete wreck, walls and roof being mingled in a mass of debris together with all the furnishings. All gone in about 15 minutes." A new stucco building would be formally dedicated April 21, 1929.

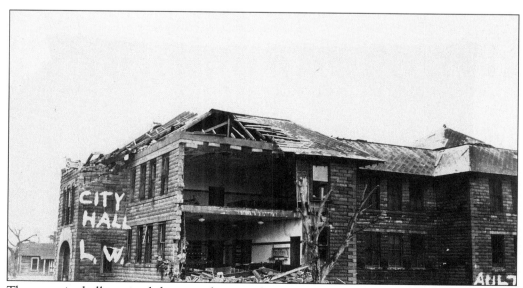

The new city hall received the most damage of any municipal building. It was declared unsafe and placarded with warnings to the public not to enter. The copper roof was almost totally destroyed, and the entire third story removed. From this photo, the pews are visible from what had been the City Commission chamber on the second floor.

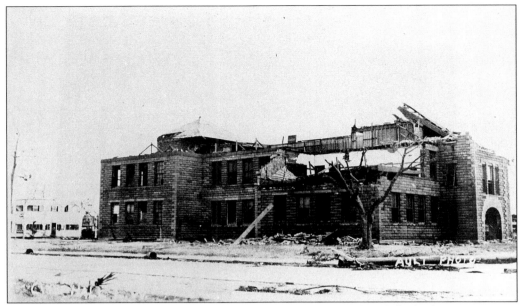

This photo shows the damage to the west side of this seemingly solidly built structure. An ordinance was soon adopted by the City Commission calling for immediate removal of all storm-wrecked buildings and rubbish from properties. By the first of November, over $600,000 in building permits had been issued for repairs.

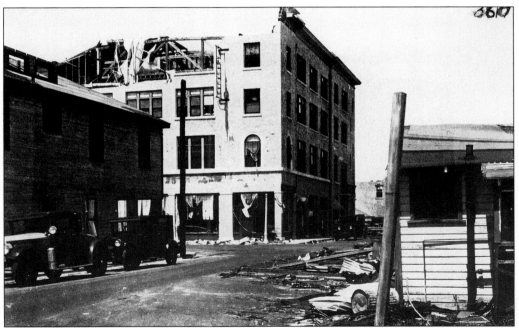

The Masonic Temple, located at "H" Street and Lake Avenue, lost most of its fourth floor. At the time, this storm was considered to be the worst natural disaster in the country's history. The loss of millions of dollars in property pales in comparison to the horrendous loss of human life. Though reports vary, to this day, all agree that on Black Sunday, over 2,000 people perished.

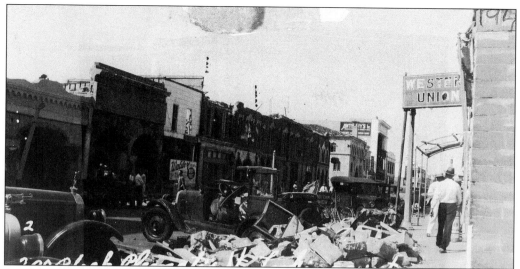

As the storm passed diagonally across South Florida, no community was spared. The winds drove Lake Okeechobee out of its bed. West Palm Beach recorded 10 inches of rain during the storm in addition to 18.42 inches for the week. The storms forward edge reached out 100 miles and had an eye 25 miles across. All wind-recording instruments were blown away.

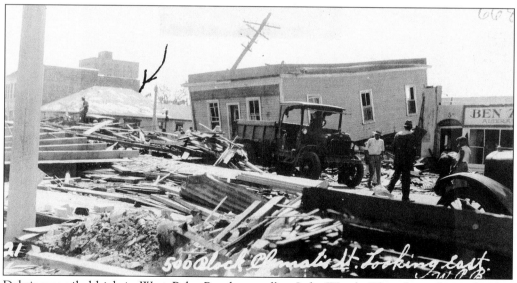

Debris was piled high in West Palm Beach as well as Lake Worth. This photo shows the 500 block of Clematis Street looking east. In addition to the Lake Worth Bridge being blown away, the Royal Palm Bridge, Southern Boulevard Bridge, and the Lantana Bridge all received heavy damage. The storm washed out 15,000 feet of Ocean Boulevard between the Casino and Lantana.

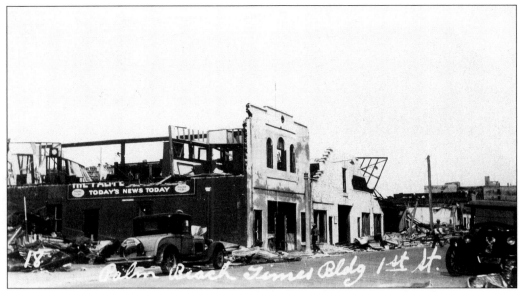

Most of the damage in West Palm Beach in the business district was in the Clematis, Datura, and First Street area. Part of the American Legion Post 12 landed in the middle of the street. Delegations from Miami soon arrived in Palm Beach County and assisted with the local relief efforts. The *Palm Beach Post* only missed one day of publication, Monday.

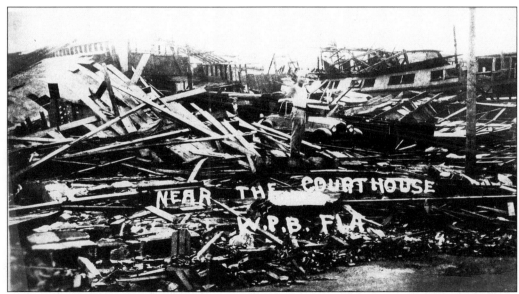

Thirteen thousand refugees were given shelter at the Red Cross in West Palm Beach. Four hundred more were sheltered at the First Methodist Church with 2,000 meals being served daily. Governor John Martin visited Belle Glade with Attorney General Fred Davis and commented, "We wouldn't have believed it if we had been told of it in Tallahassee. It is the worst sight I have ever seen."

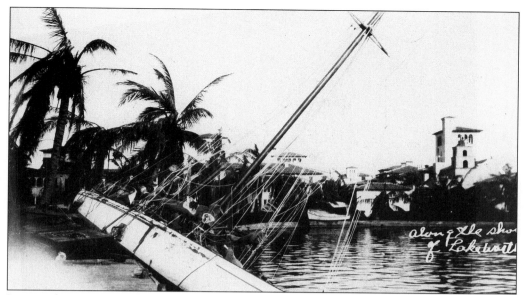

In one place in Palm Beach, waters from the lake and the ocean met, and some homes had inches of mud on the floors after it was over. The wind seriously damaged the Royal Poinciana Hotel, and it was condemned by its insurance company. Hundreds of boats were wrecked, sunk, or thrown up on pilings. Shown here is the wreck of a publisher's yacht, the *Marchioness*. The Everglades Club is in the background, across Lake Worth.

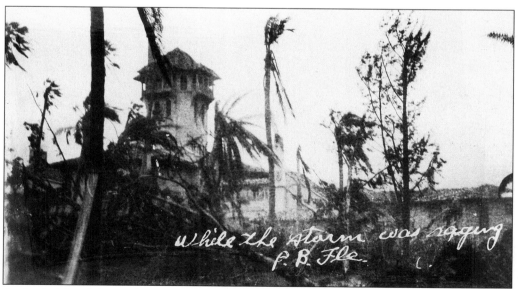

At the height of the storm, trees were stripped of their foliage and snapped like twigs. Marjorie Merriweather Post's estate, Mara Lago, is shown in the background. Reports on damage in Palm Beach County showed 11,389 houses damaged, 3,584 homes destroyed, 4,008 families homeless, and 16,032 persons homeless.

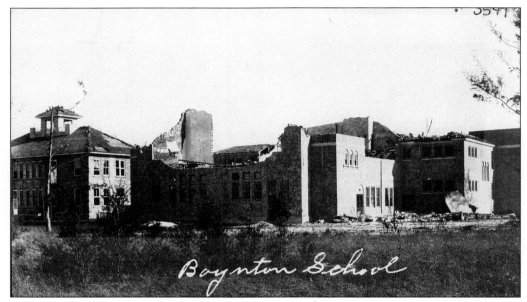

Boynton School

As far south as Pompano Beach, there was hurricane damage to some extent. The Boynton Beach schoolhouse received heavy damage, and four deaths were reported in Delray. The tremendous loss of life was due to flooding at Lake Okeechobee. It would be days before news of the tragedy in the Glades area would be broadcast.

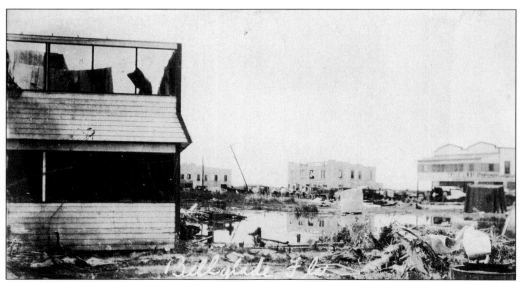

Belle Glade, Fla.

Belle Glade is 42 miles southeast of Lake Worth on Lake Okeechobee. The rains caused the inadequate dikes to give way sending a 6-foot wall of water crashing down and flooding the area for 20 miles, up to 11 feet deep in places. Residents were trapped in the darkness and drowned in their fields and shacks. Few buildings were built to withstand high winds and few did.

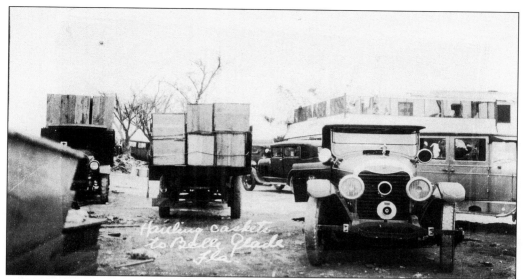

Entire families and communities were literally washed away. Lake Okeechobee was laid to waste. In the following days, it became critical to organize a pick up and to bury the dead, mostly black farm workers. Conditions in the Everglades were horrible. Relief workers went into a heat and stench that was almost unbearable and worked hour after hour pulling bodies out of the muck.

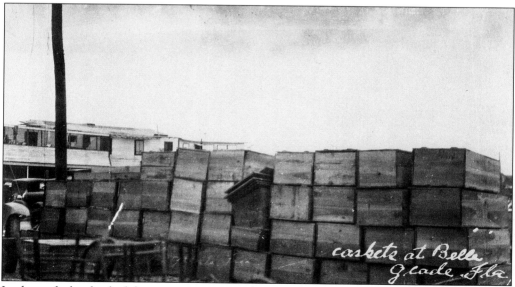

In the end, the dead of the two races were undistinguishable. Soon, funeral pyres began to dot the lake. Great piles of bodies, ten or a dozen at a time, were heaped up and crude oil poured on the lot. It was necessary to dispose of the bodies to relieve sanitary conditions and avoid water contamination. Cremation was the only means available.

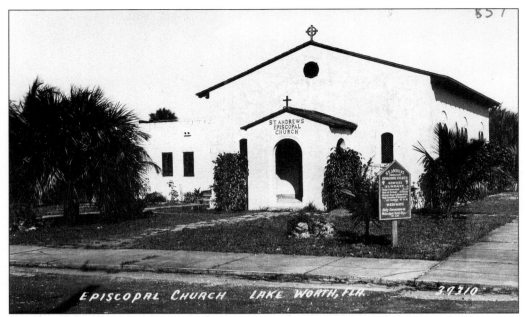

Much work would need to be done to recover from the chaos and loss that occurred that terrible day, and many gave up and went back north. Those who stayed rebuilt and reclaimed their lives. The new St. Andrews Episcopal Church was built within a few months with donations received from all across the country.

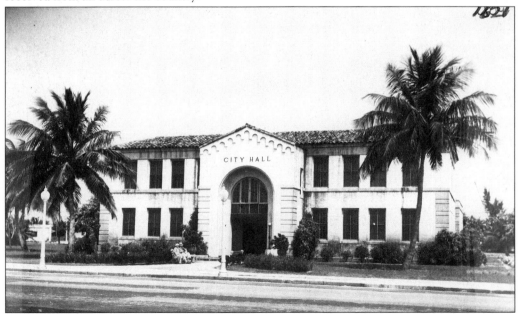

By April 15, 1929, it was business as usual at the new city hall. Totally remodeled by Floyd Kings, the building contained city government offices, utility records, and the Municipal Library. One local resident commented after the storm, "The climate is so wonderful, the attractions of Florida so many and varied, that I doubt if even the threat of another hurricane could move me out."

Four

THE DEPRESSION YEARS

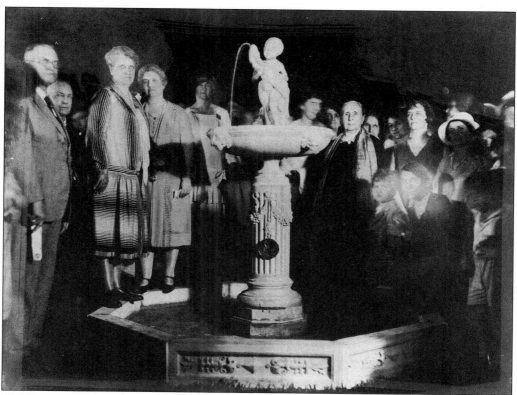

The Business and Professional Women's Club was organized on June 1, 1926, with 74 charter members. Mary Randolph, then state president, and Edith Fricke, district manager, were the organizers, with B. Lewis, the first local president. Club members are shown here at the dedication of an Addison Mizner birdbath at city hall.

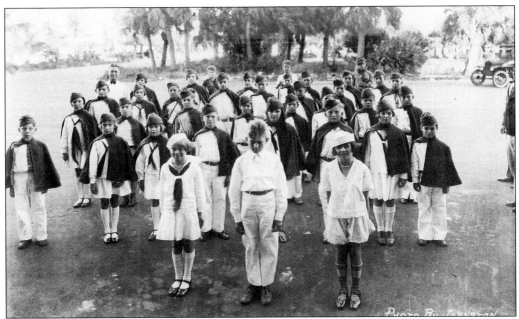

The Harmonica Band was formed in 1927. It began with 35 boys and girls from ages seven to 15, and, by 1929, it was composed of 150 children. They are shown here on their way to a competition against 24 other state groups in St. Petersburg. They won the gold medal and $50. In February 1929, Herbert Hoover visited Miami, and the band was invited to participate in a parade and entertain the President.

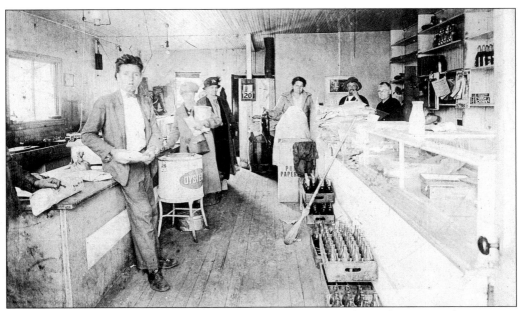

Dad Hook's Fish Market was a small no-frills family business located at 722 Lake Avenue. Charles and Mattie Hooks, shown here at far right, were the owners and purchased much of their merchandise from local fishermen.

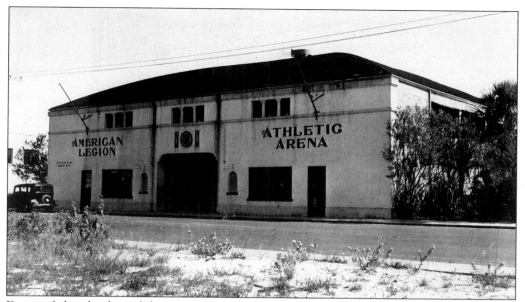

Despite failing banks and the unrest and uncertainty after the hurricane, the American Legion opened its $16,000 Athletic Arena on May 24, 1929. Wrestling matches continued to be a popular entertainment. Patrons came from all over the area as far away as Miami. The arena was located on Lucerne Avenue near "K" Street.

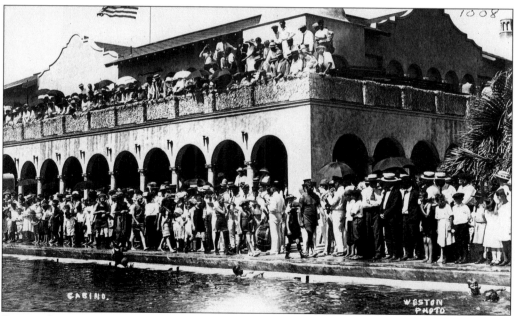

During the Depression years, when money was tight, the beach and the pool were the ideal places to go to swim, relax, or party. Large crowds were always found at the beach. The *Lake Worth Herald* reported on February 7, 1930, that over 800 people were on the beach and that "The unusual heavy crowds at the beach is another proof that the city is entertaining more winter visitors this season than in the last four years."

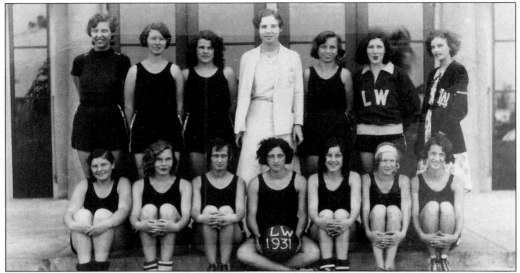

The members of the 1931 Lake Worth High School's girls basketball team are as follows: (seated) Willette Pumphrey (forward), Virginia O'Quinn (guard), Rosie Fritz (jumping center), Gladys Glunt (guard), Mary Hunter (forward), Winnie Gensen (jumping center), and Cara Glunt (running center); (standing) Jean Childs (jumping center), Irvene Childs (guard), Dorothy Perkins (guard), Coach Garnett, Ruth Hagg (forward), Kat Fergan (running center), and Hennie Lee Baker (manager).

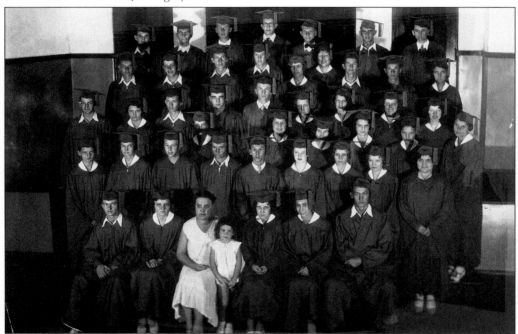

The Class of 1932 at Lake Worth High School poses here. It was the largest graduating class in the school's history. A little history is included in the class, as well. One of the graduates, Jean Childs, daughter of pioneers Mr. and Mrs. G.S. Childs, was the first girl born in Lake Worth and the first child born in Lake Worth to graduate from the school.

These boys are members of the 1932 Lake Worth High School Spanish class. They look carefree; however, the economy is in serious condition. Men and women in Palm Beach County were given employment through allotment programs. The first allotment to Lake Worth was $899.64 for work on the high school grounds and athletic field.

In July of 1926, residents began a movement to establish an Elks Lodge in Lake Worth. By February 1927, 600 Elks from around the state gathered to combine the 59th birthday of "Elkdom" and the institution of Lake Worth as its newest lodge. By 1929 they remodeled and moved into the old Liberty Theater Building. This group is shown in 1932 at an initiation in West Palm Beach.

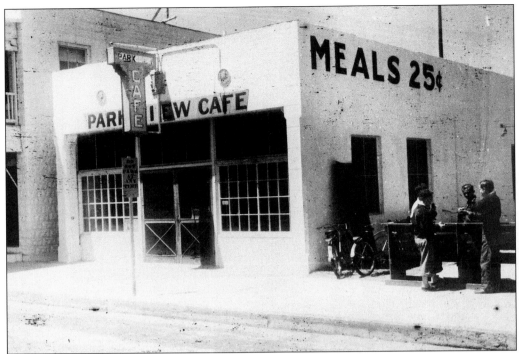

The Parkview Cafe opened across Lucerne Avenue from city hall at the height of the Depression. A 2-foot-tall sign on the building advertised meals for 25¢. Times were tough, and unemployment was high. City employees received large pay cuts in April of 1933. Cuts affected every employee in the city.

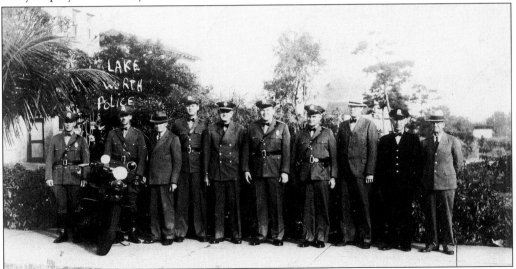

The Lake Worth Police Department, c. 1934, is ready to serve and defend. Pictured here, from left to right, are as follows: Sam Schlappich, Tom Stearns, Alex Drake (municipal judge), Alfred Buckman, Chief G.S. Sanders, Hank Hall, Frank Fales, David Small, Mike Sorge, and Frank Houghton. During this time, the City Penal Code required city prisoners serving work sentences to wear a ball and chain.

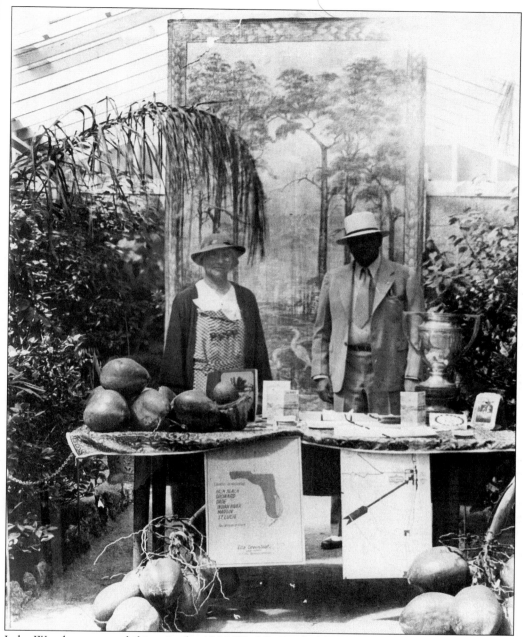

Lake Worth was an exhibitor in the 1934 World's Fair held in Chicago. They were part of the Century of Progress in the Florida Hall at the Fair. Literature on Florida was in big demand, and 85,000 people visited the exhibit on one Sunday. The average daily attendance was 50,000. Mr. C.K. Simon, president of the chamber of commerce, poses at the exhibit with Mrs. Ella T. Greenleaf, secretary of the chamber. The wall hanging behind them was made by Mrs. Ella E. Menoher.

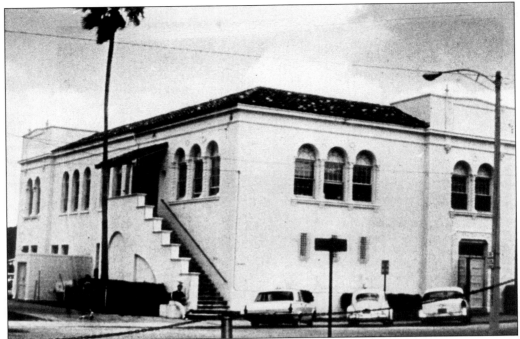

Palm Beach Community College was opened in 1933 on Gardenia Street in West Palm Beach. It was Florida's first community college, and its first graduating class consisted of three people. Many building projects were soon to be implemented and financed by President Roosevelt's Public Works Administration. By the end of 1933, over $1,089,207 in projects had been approved for Palm Beach County.

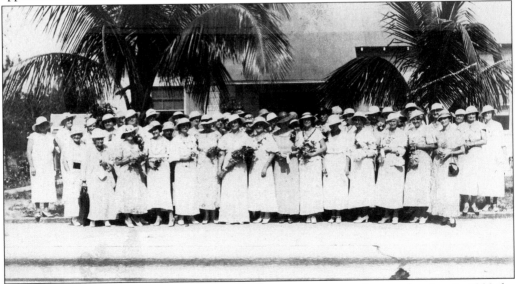

Even in the midst of the Depression, Lake Worth civic groups were busy and active. In 1932 the Lake Worth Woman's Club built a new clubhouse for their activities, as the original 1915 building was destroyed in the hurricane. The $400 mortgage was not paid off for four years. The ladies shown here are attending their Annual May Luncheon and Installation on May 13, 1934.

Prohibition is over, and this fellow has the bullhorn to prove it. Edward Andrews was president of South East Ice & Storage on North Dixie Highway at Eighteenth Avenue. The U.S. government repealed prohibition in 1933. The State of Florida prohibition amendment did not expire until November 6, 1934, the date of the general election. It was voted upon and repealed overwhelmingly.

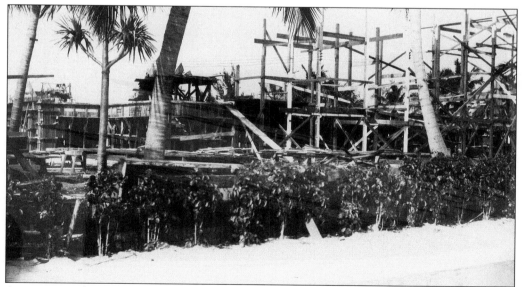

A new city auditorium to cost $69,956 was among 33 civil projects in Palm Beach County. The building was begun early in 1933. The WPA program of providing work at minimum wage put thousands to work across the state. By March the program was reorganized. Work had been halted on the Auditorium several times, and workers were laid off. The federal government had spent $15,707,035.22 in Florida by April 1934.

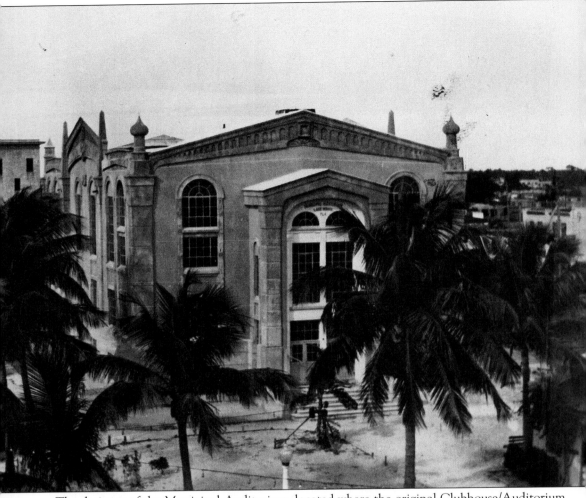

The designer of the Municipal Auditorium, located where the original Clubhouse/Auditorium had been, was G. Sherman Childs. City government offices remained at the city hall. This facility would serve primarily as a cultural and social facility. After numerous delays spanning almost two years, it was dedicated in November 1935 in a formal ceremony including all previous mayors serving since 1912. The chamber of commerce building is visible at the lower right of the photo.

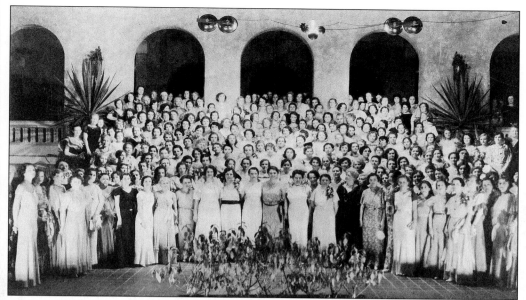

During the Depression years, the Business and Professional Women's Club membership declined, as many members lost their jobs and moved elsewhere. They reduced their dues and assisted in finding members employment as well as continuing their civic work. Here is the group in Orlando for their 1934 state convention.

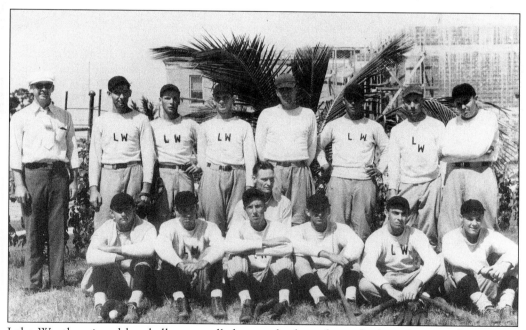

Lake Worth enjoyed baseball games all the way back to the early days. In 1934 the semipro Ramblers team formed. Profits were shared. Shortstop Orrie Simonds got paid $15 in 1934. One player noted, "You had to love baseball to wear a Rambler uniform made of 100% wool, you could lose 8 lbs. on a Sunday afternoon."

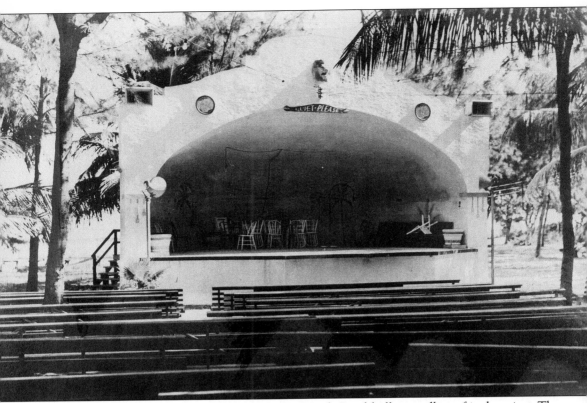

Residents enjoyed many concerts at the Lake Worth Bandshell, regardless of its location. The original location for concerts had been on the campus of the Second School. It was then moved to a location at the corner of Lucerne and "J" Streets. Eventually it was moved to the Auditorium grounds on Dixie Highway in 1923. On January 30, 1931, a new bandshell had been dedicated north of the Auditorium, directly east of the shuffleboard courts. The following year, that entire block was formally dedicated as Pioneer Park in honor of the city's first settlers. With construction of the new Municipal Auditorium underway, it was decided to make the final home of the bandshell the lakefront park directly across from the Gulfstream Hotel, donated to the City by the Palm Beach Farms Company. In August 1937, the City formally adopted a resolution to officially name the park Bryant Park, after Harold J. Bryant of Bryant & Greenwood, Lake Worth's first and biggest promoters.

The original wooden 1919 bridge had been repaired after the 1928 hurricane; however, it became necessary for a modern bridge. The War Department issued a permit for a new bridge in 1933. Construction began in 1936, and it was completed in 1937. This view is looking east from Ocean Drive.

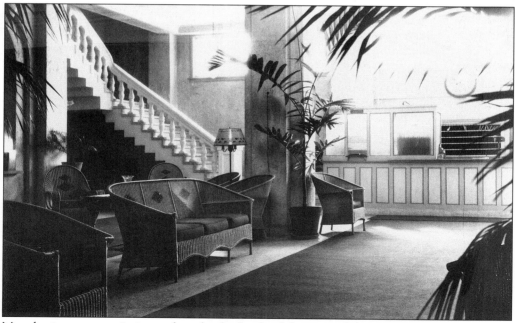

Most businesses were in jeopardy as bank after bank began to fail in South Florida, including the Gulfstream Hotel. The hurricane of 1928 caused major damage to the top floors. The Gulfstream Hotel soon closed its doors permanently and remained closed until 1936. The hotel was sold for taxes on the steps of the Palm Beach County Courthouse. The $600,000 hotel was purchased for $25,000.

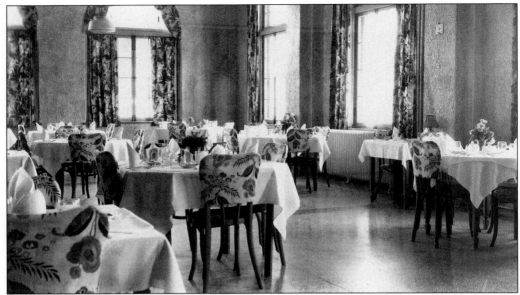

General Richard C. Marshall II and Colonel H.C. Maddux formed the Hygeia Hotel Company and were now the proud owners of the ailing Gulfstream. A complete renovation had to be done, due to hurricane damage and years of neglect. Miraculously, within six months, the hotel was reopened and became a success as the economy began to improve. This dining room photo was taken on December 3, 1937.

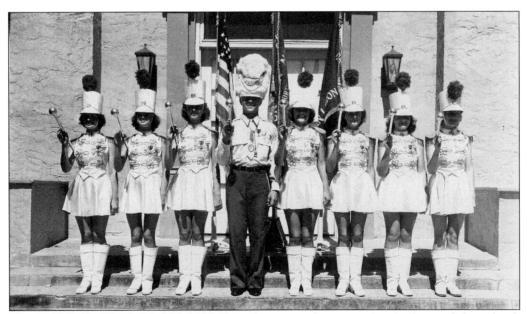

The 1938 Lake Worth High School Trocadettes stand at attention in front of the school. Improvements to the school in 1938 included a WPA project for a $7,722 parking lot and general beautification. Also the American Legion Post and the Lake Worth Ramblers baseball team paid for a new roof for the athletic field grandstand. On June 2, 1938, 27 girls and 31 boys graduated.

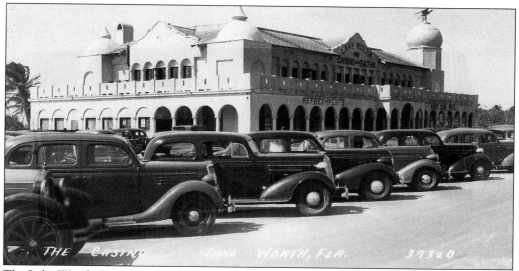

The Lake Worth Casino and Baths was "redesigned" by the 1928 hurricane. The dome with an eagle replaced the tower and flagpole that had been blown away in the storm. By 1937 it had been redesigned again, and all four corners had been removed and simplified.

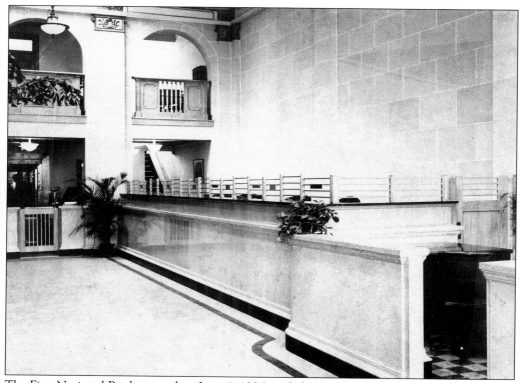

The First National Bank opened on June 4, 1936, with $88,000 in deposits at 806 Lake Avenue in the old First Bank of Lake Worth location. The beautiful bank lobby is shown here. Wiley R. Reynolds was the chairman of the board. Roy E. Garnett was president. By December, deposits had increased to $383,436.

In 1937 the First Federal Savings and Loan Association opened in the south wing of the Reanno Building at Lake and Dixie Highway. Later that year, the bank moved to this location at 907 Lake Avenue. Mr. R.E. Branch managed the office, being its sole employee. His duties ranged from managing the office to serving as janitor, teller, loan officer, and bookkeeper.

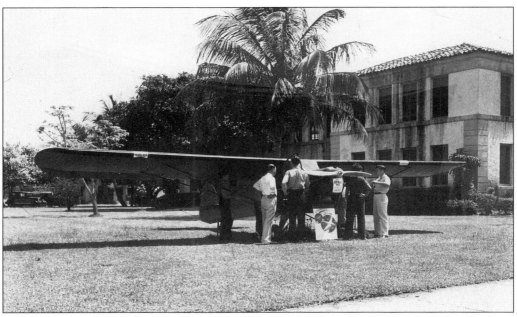

The First Direct Airmail Service began in February 1931. In May 1938, during National Air Mail Week, A.B. and Meale Engle flew their airplane to the golf course and taxied up Lake Avenue to the city hall, where stamps were sold from the plane all day. No damage resulted until the plane was trucked back to their airport and broke a wing.

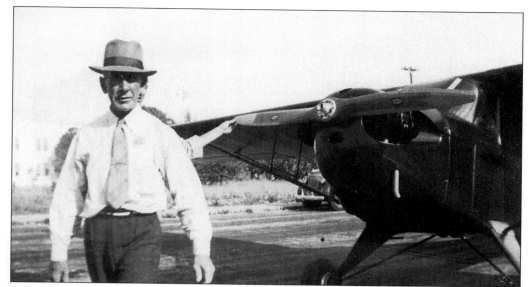

A.B. and Meale Engle pioneered in aviation in Lake Worth. In 1935 they purchased 100 acres west of town for the first (last and only) airport in Lake Worth. They had 15 airplanes in residence and put on air shows and circuses. Lake Worth was, literally, put on the map with United States Aerial maps indicating the airport.

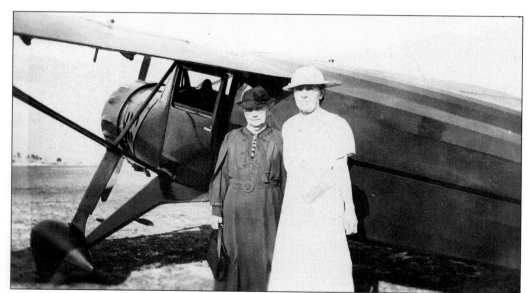

Mrs. Elizabeth Agner, age 90, and her daughter, age 66, are photographed after their first airplane ride with A.B. Engle at Engles airport. The back of this photo says, "Before their flight, timid, after the flight, air minded." Meale Engle estimated that they flew over 1,000 people, gratis, over Lake Worth and Palm Beach County.

The Engle's Airport was located in the 2,000 block of Second Avenue North. They collected money to give Lake Worth its first community Christmas tree and over 1,400 free bags of candy and oranges to the children. They also sponsored a ground and flying school at Lake Worth High School from which 161 graduated.

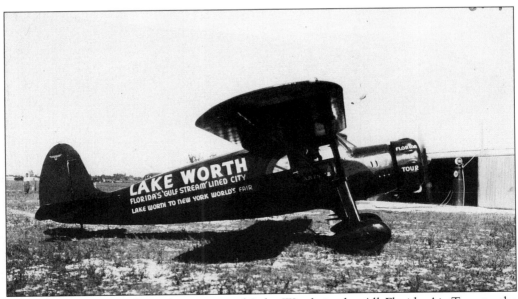

In 1939 A.B. and Meale Engle represented Lake Worth in the All Florida Air Tour to the World's Fair in New York with 72 planes and 227 passengers. All made safe landings, and Meale's journal was published in the local newspaper.

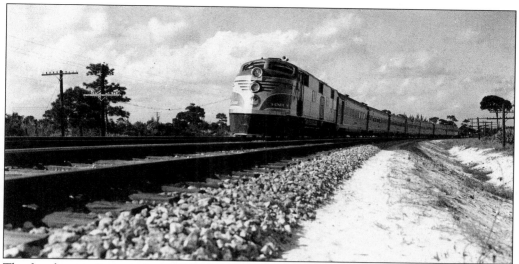

The first locomotives on the FEC Railway were wood burners. Eventually, they changed from coal to oil. Coal had to be brought in by ship, so converting to oil was advantageous. The FEC Railway acquired its first diesel electric locomotive in 1939. The *Dixie Flagler*, shown here, was one of the first of the new stainless steel stream-lined trains.

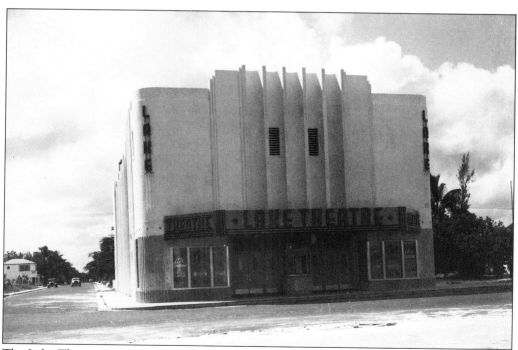

The Lake Theater was located at 601 Lake Avenue and was built in 1939. It officially opened on February 29, 1940. The theater was 125 feet long, 54 feet wide, and 34 feet high. It showed only "highclass motion pictures." It was owned by the Sparks Theater chain. Alex R. Nininger was the manager.

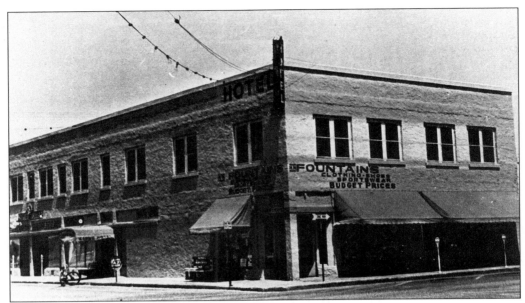

Fountains Department Store was a Lake Worth institution for many years. It opened in 1939 as the Great Depression was finally ending. Lake Worth was thriving, and the family store at 728 Lake Avenue offered clothing, shoes, and sports wear at budget prices. The Cleve Hotel was located upstairs.

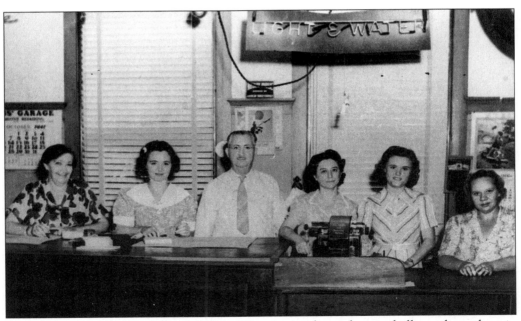

The employees of the city Light and Water Department, located at city hall, are shown here in 1940. They are, from left to right, as follows: Lena Barnette, Helen Ellis, Elmar Farrow, Nadine Willard, Carman Wilhite, and Elizabeth Thurber. The City operated its own water and power plant. Additionally, for a time, it conveniently sold appliances as well. The city hall showroom sold everything from ranges, irons, and refrigerators to toasters, roasters, and percolators.

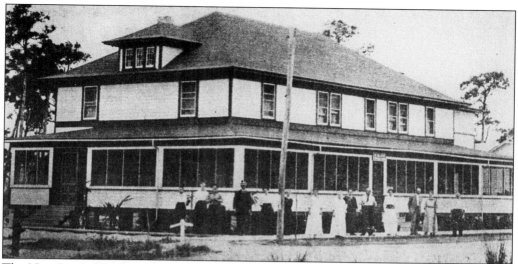

The New Jersey Hotel was located at 123 Lake Avenue at South "P" Street, today known as Palmway. Mrs. Mary E. Lloyd was the proprietor, and Mr. William S. Lloyd was the manager. It would later be known as the Lake Worth Inn.

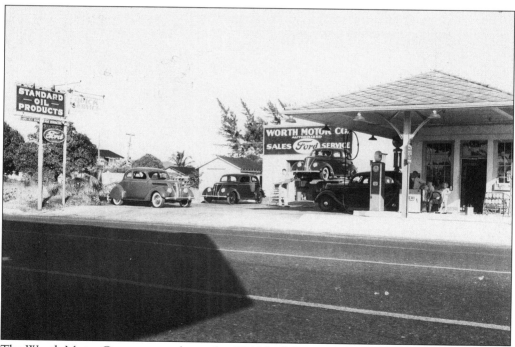

The Worth Motor Company was located at 304 North Dixie Highway and was managed by Lew Noyes. They offered quick service on all makes of cars and Standard Oil products. They were an authorized Ford service station. Numerous businesses used the name Worth in their companies after the general and the city.

The Toggery Shop was located at 705 Lake Avenue and sold ladies furnishings. Next door was the Periwinkle Inn and Dining Room operated by Mrs. Mildred Clayton. Wertz Beauty Salon and Earl L. Pierce Barber and News Dealer were at 709 and 711 Lake Avenue.

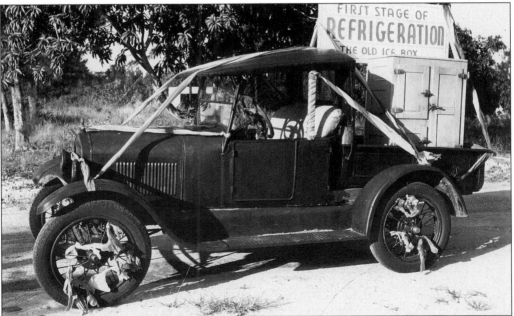

The Southeastern Ice and Cold Storage Company reminisces about the old time iceboxes with this display in a parade. The new Coolerator, the "airconditioned" ice refrigerators, were just becoming popular. In the past, crude flannel-covered boxes with pans of water on top had been made to cool foods.

Five

WAR AND BEYOND

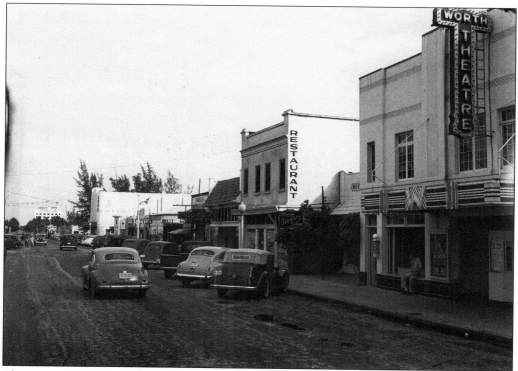

This view of Lake Avenue looking east shows the close proximity of the Worth Theater and the Lake Theater down the block. The Worth Theater was originally the Oakley Theater. It changed hands and was remodeled and named the Worth. It showed first run pictures and Saturday matinees.

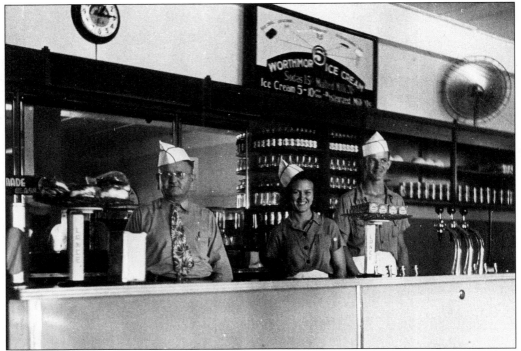

The Worthmor Ice Cream Company operated an ice cream parlor and factory at 27 South Dixie Highway. Anton L. Guentner was the owner. The shop offered ice cream for 5¢, ice cream sodas for 15¢, malted milk for 20¢, and pasteurized milk for 10¢ in 1940.

Ideal Drug Store was across from the municipal auditorium at 830 Lake Avenue. The location had previously been Engram's Drug Store, and in the early days, the corner had been known as Engram's corner. The store also had a lunch counter.

This view of Lake Avenue heading east shows, at the left, the W.W. Mac Store at 710 Lake Avenue. The owner was W.W. McClellan. It had been a Ben Franklin store at one time. At 712 Lake Avenue was the Geibel Photo Service, and next door was the old Liberty Theater.

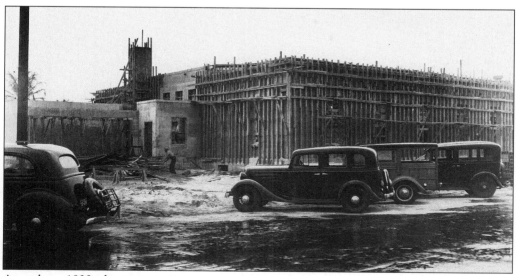

As early as 1932, the city was attempting to secure a permanent post office. At this time, the post office was renting space from the Scottish Rite Temple at "H" Street and Lake Avenue. The Garner Emergency Relief Act provided that preference be given for government building in areas where current facilities were rental. The post office construction is shown here at Lucerne Avenue and "J" Streets.

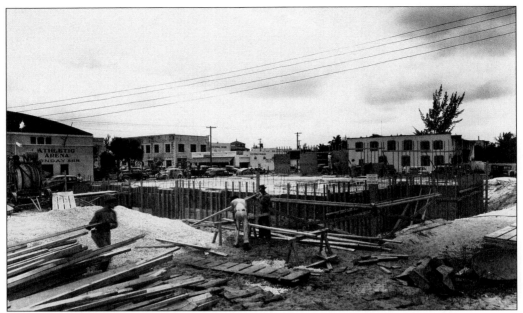

The lot was purchased for the new post office for $13,250. Construction did not begin until late January 1940. This view, looking southwest, shows construction in the forefront. At left is the American Legion Athletic Arena, the rear of the First National Bank, and at the right is the two-story Shoupe Hotel.

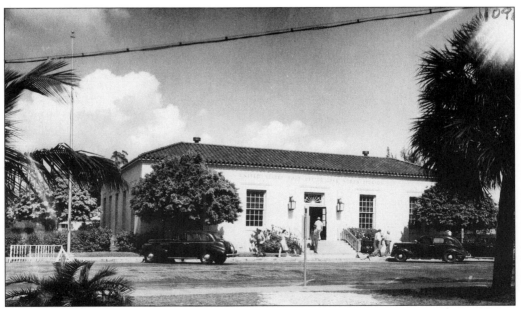

The new post office building was dedicated on July 12, 1940, with a large open house ceremony. The event was attended by many residents as well as Congressman A. Pat Cannon, Congressman J. Mark Wilcox, and a Post Office Department representative. The building's cost was $68,000.

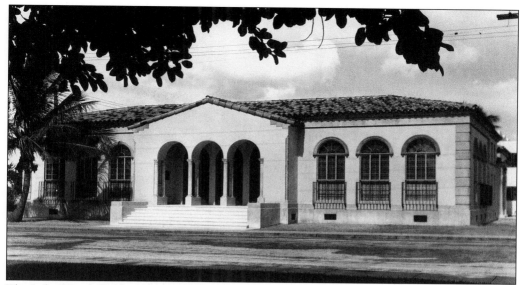

The Lake Worth Public Library was dedicated August 12, 1941, and opened with 10,000 books. The building was 60 by 70 feet and was designed by Edgar S. Wortman to complement city hall across "M" Street. Attempts were made for the library to be a memorial to Major William Jenkins Worth. Although the House and Senate passed the measure, it was vetoed by President Roosevelt.

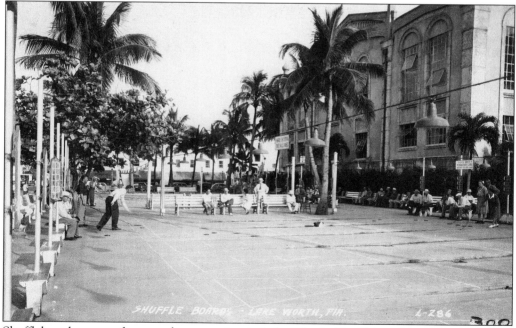

Shuffleboard was another popular recreation in Lake Worth. Shuffleboard courts were located on the north side of the municipal auditorium. It was generally considered a sport in which retirees participated; however, even the younger set got involved. Many tournaments were held at the courts, bringing in players from a wide area.

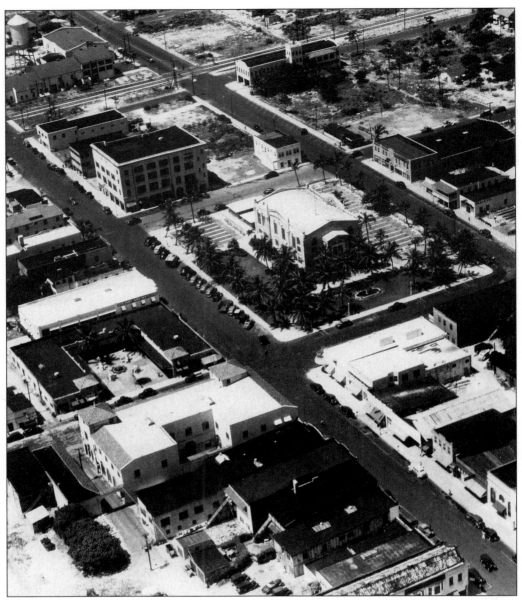

The business community had grown tremendously since those early "horse and buggy" days. Lake and Lucerne Avenues are shown here, looking west towards the railroad tracks. The municipal auditorium is at the center at Dixie Highway. The city population in 1940 was 7,256. The tax assessment roll was $3,283,610. The fire station is at the top at Lucerne and the railroad tracks. Diagonally across the tracks with the water tower is the municipal light and water plant.

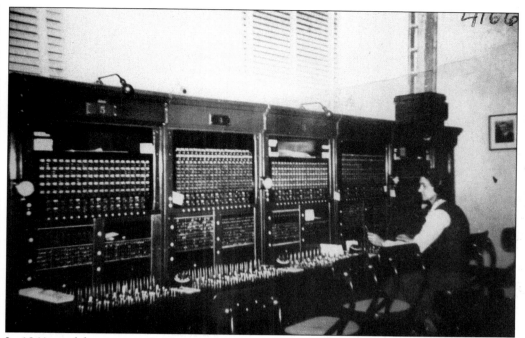

In 1941 a celebration was held to commemorate the installation of the 1,000th telephone in Lake Worth. In attendance was W.E. Horsman, who had owned the first telephone company in town and had installed the first telephone switchboard. The phone company was located at Second Avenue North and "K" Street. Ralsa Ruth is at work on the switchboard.

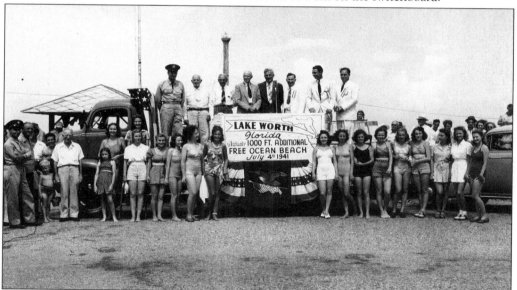

It was beginning to appear inevitable that the United States would enter WW II. Poland's army had been squashed in 1939 in 27 days, and committees sprang up nationwide, debating the drift toward war. The Fourth of July celebration of 1941 was patriotic in theme, and the entire city was red, white, and blue. The city recently purchased 1,000 feet of ocean-front property, and its dedication was a high point in the festivities.

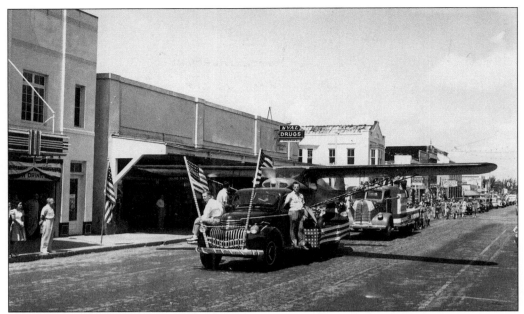

The citywide Fourth of July celebration in 1941 was considered one of the most successful in the history of the city. The Lions Club had organized the event and assigned various phases to other local organizations. A spectacular parade through the streets kicked off the day's activities, led by Lion Chief of Police G.S. Sanders.

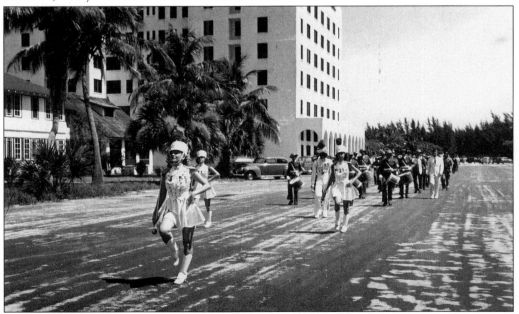

City and county officials also took part in the parade, followed by a color guard and Sons of the Legion Drum and Bugle Corps. Also participating were the American Legion, VFW, Spanish American War Veterans of Foreign Wars, and the 317th Signal Company from nearby Morrison Field in West Palm Beach. The parade journeyed to Bryant Park where a patriotic address was broadcast by radio.

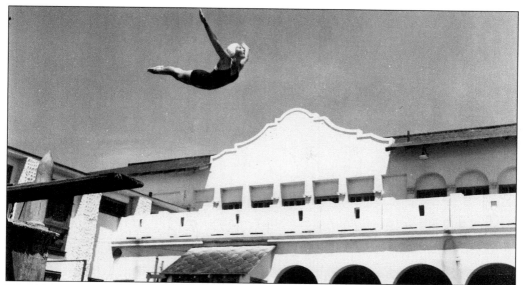

Patriotic music was played by an orchestra, and a group singing of the Star Spangled Banner as well as a mass Pledge of Allegiance took place. After a luncheon for dignitaries, activities commenced at the Casino. Athletic contests were held including foot races, swimming and diving contests, water polo games, and a bicycle race.

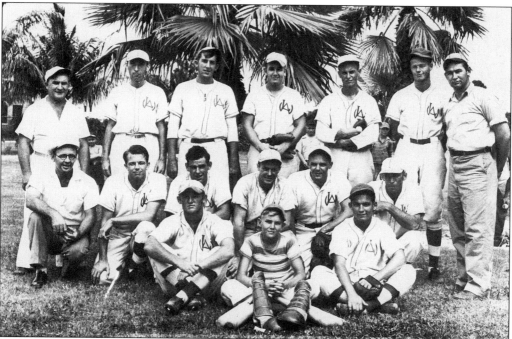

By December, the United States was at war. It had been hoped that it could be avoided, but after Pearl Harbor, even the staunchest isolationists were in agreement. Montana Senator Burton K. Wheeler, initially against involvement, said after Pearl Harbor, "The only thing to do now is to lick the hell out of them." The semipro Ramblers ceased play for the duration of the war as many of the boys went into service.

Mrs. Mary E. Lloyd and her husband owned the New Jersey Hotel. Mary, 85 years of age, is shown in this photo volunteering for service in the fourth war in her lifetime. Also, shown at their right, are Tillie Lloyd Richardson and Marjorie Richardson, the youngest registrar at age 19. On her left are Herb Evans, city chairman, and Mayor Grady H. Brantley.

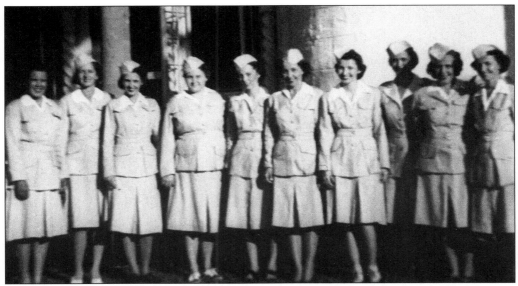

The residents of Lake Worth have always been known for their patriotism and civic mindedness. Every organization and group in town contributed to the war effort as best as they could. The Lake Worth Ambulance Corps of WW II are shown here, although not all are identified. June Boutwell, Dorothy Shamo, and Margaret Waddell are among the group.

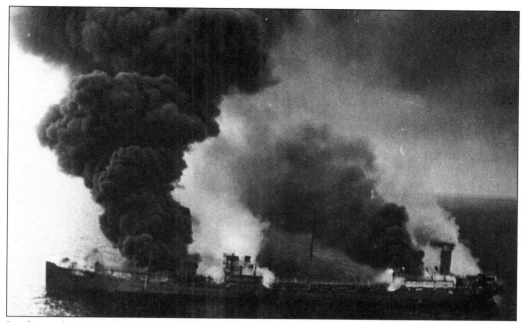

In the early years of the war, German submarines were very active in the shipping lanes off Florida. During the week of May 4, 1942, seven ships were torpedoed off the coast. Lost were the *Eclipse*, *Del Isle*, *Java Arrow*, *Lubrafol*, *Amazonas*, *Helsey*, and the *Ohioan*.

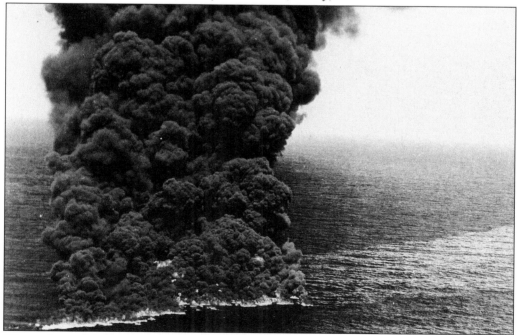

Often after a ship had been sunk, the submarine would surface, and the survivors would be gunned down. Enemy saboteurs had been coming ashore, and the Army requested the closure of area beaches as a precaution. Ocean Boulevard was closed at night, and all bridges were guarded by the Coast Guard.

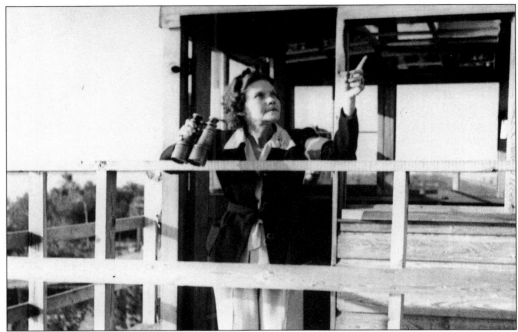

Over 5,000 sailors were killed in Florida coastal attacks by the enemy. Coastal lookout stations, mounted patrols, and attack dogs were set up along the Florida coast. Civilian volunteers manned 60 spotter stations, including one at the Lake Worth Beach lifeguard tower.

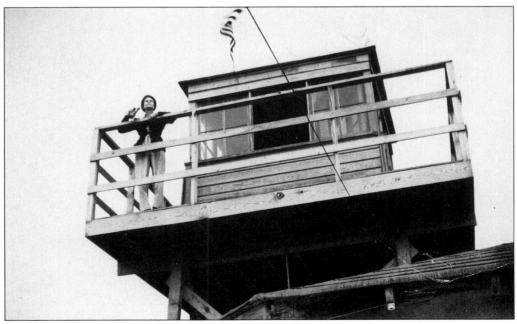

The duty of the lookout observers was to spot enemy aircraft, submarine, or otherwise suspicious activity. On a quiet night, tower volunteers could hear the diesels of submarines cruising offshore. Occasionally, they could be seen signaling the shore with signal lights.

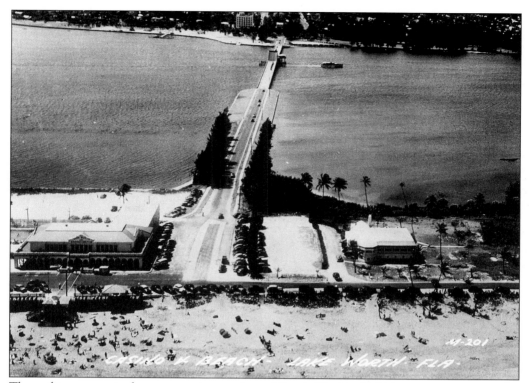

The military soon took over a major portion of South Florida facilities as training posts for armed services. The Casino Ballroom was closed due to a dimout. The entire Atlantic and Gulf Coasts were dimmed out to prevent silhouetting ships against shore lights. All bandshell entertainment was concluded before dark.

The South Grade Elementary School Junior Scrappers formed a "V" for victory in front of their school in 1942. Scrap metal drives took place all over the city. Paper and rubber were also collected to be recycled into war goods and ammunition. Lake Worth collected over 50,000 pounds of scrap.

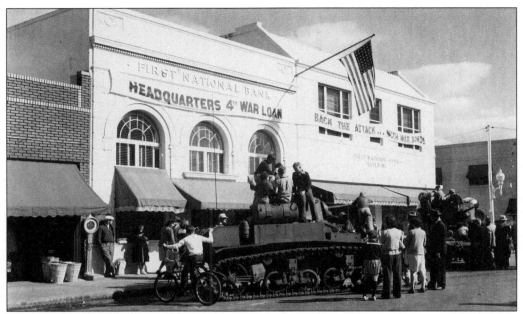

United States war bonds were being sold at the First National Bank on Lake Avenue. A tank, out in front of the bank, caused quite a stir, and sales were brisk. The banner on the front of the bank read "Headquarters 4th War Loan, Back The Attack, With War Bonds."

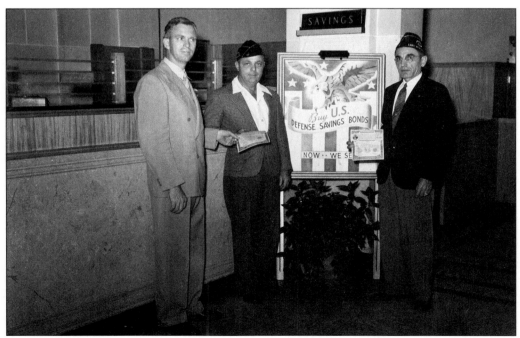

Continuing bond drives financed the war and were successful in Lake Worth. The Lake Worth Elks Lodge organized the fourth War Loan Bond Drive and encouraged their members to buy bonds. Members purchased over $14,000 in war bonds.

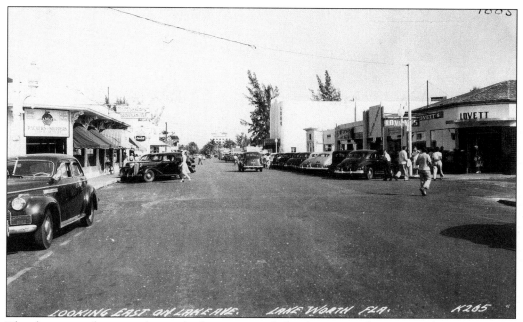

The downtown business district looking east on Lake Avenue is shown. On the right, in the distance is the Gulfstream Hotel, which had to adjust to "life during wartime." Military guests were given a 25 percent discount. Guests were required to bring their ration books, and no room service was available.

The 1942 Trojan football team of Lake Worth High School is shown on the playing field. Coach Buddy Goodell is on the right. The Trojans were undefeated 100 that season. All of the games had to be played in the afternoons because of the dimout.

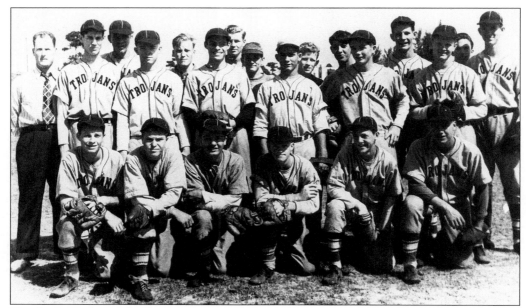

The first casualty in the line of duty in Lake Worth was Donald Earnest Lee, 21, a radioman second class with patrol bombers in the Philippines. The first Red Cross worker killed in combat was 35-year-old Lake Worth High School coach Russell Lynwood Bullard, shown on the left with his team.

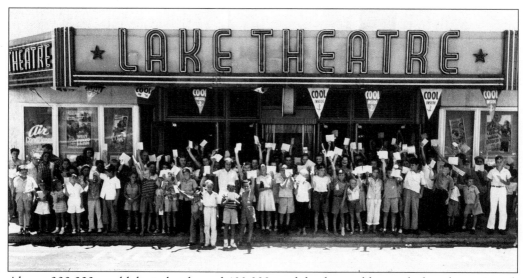

Almost 300,000 would die in battle, and 400,000 total deaths would occur before the war's end. Another local casualty was Alexander (Sandy) Nininger Jr. His father was the manager of the Lake Theater. Sandy won the first Medal of Honor, posthumously, for heroism on Bataan.

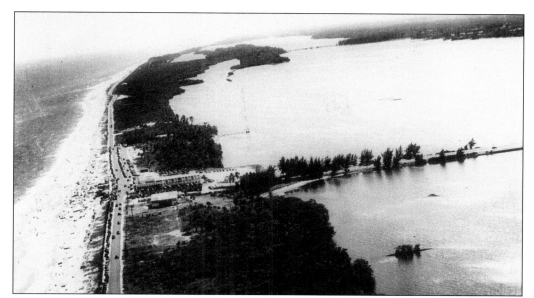

The Casino ballroom reopened in 1944, as the tide of the war was turning. Windows in Palm Beach had been painted black, and automobiles had to drive with the top half of their headlights blackened. The Navy Department took over Flagler's Whitehall, and the U.S. Army Corp used the Palm Beach Hilton as an evac hospital.

The wacky looking fellow in the center is comedian Joe E. Brown. He was on Saipan entertaining the troops shortly before the end of the war. The handsome sailor in the white cap, at the lower right, is Robert McMillan, local resident.

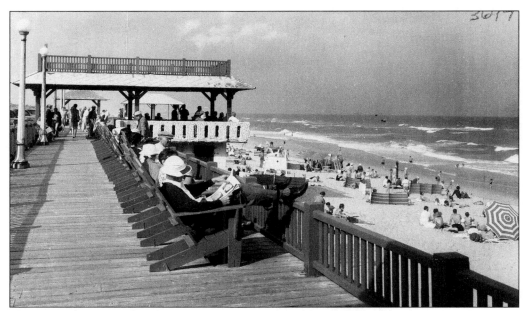

The Casino continued to be a center of activity and leisure. Beach erosion issues were just beginning to be addressed, as well as restoration of the Ocean Boulevard. After a washout, traffic had to be rerouted over private property. Eventually the road would have to be permanently rerouted away from the ocean.

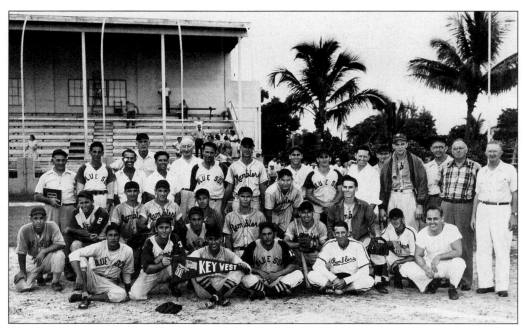

Two big sporting events took place on Labor Day, 1946. The first ocean swimming marathon from the Palm Beach Pier to the Lake Worth Casino was held since the war began. This was followed by a special game between the Lake Worth Ramblers and the Key West Conchs with New York Giant Swede Hanson pitching.

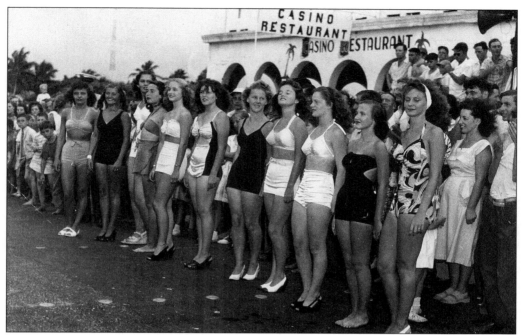

The first big celebration since before the war was held on July 4, 1947. A number of events took place all over the city including a beauty pageant and swimming contest. Sporting events were held at Russ Bullard Field at the high school as well as a watermelon-eating contest.

The Lake Worth Ramblers resumed play after the war and played until disbanding in 1949, when the Florida International Pro League came into being. They had a 197-61 record. Two team members, Mayo Smith and Andy "Swede" Hansen, went on to the majors. The team and their wives are dining with the Key West team in Key West. On the lower right is the mayor of Key West.

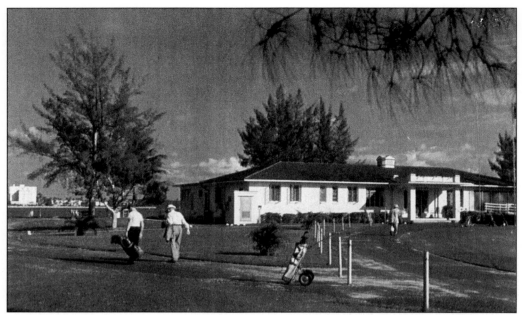

A new clubhouse was built at the golf course in 1947 at the east end of Seventh Avenue North. That same year, the course became an 18-hole course. Improvements were also made to make the course one of the finest on the Florida East Coast.

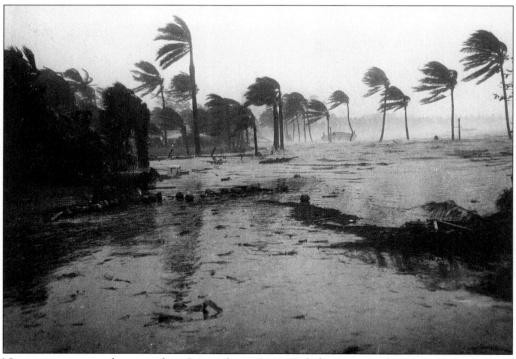

Nineteen years to the very day, September 16, 1947, lightning struck again in the form of another hurricane. It could not even remotely compare to the 1928 hurricane as far as damage or fatalities. It was more of an inconvenience than catastrophe.

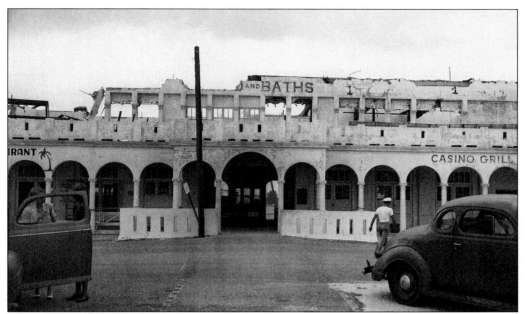

The hurricane destroyed the roof and damaged the second floor of the Casino. Prior to receiving an engineering report, it was thought likely that the building may have to be condemned. The building was repaired and put back into service pending a complete renovation.

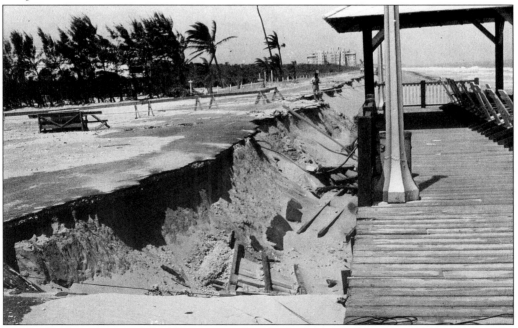

Ocean Boulevard was washed out, again, by the hurricane. This part of the road at the boardwalk is directly opposite the Casino building. Damages to property were estimated at $600,000, mostly due to faulty roof shingles. The city had to request from the War Assets Administration bulldozers, loaders, dump trucks, cranes, and equipment for street repairs.

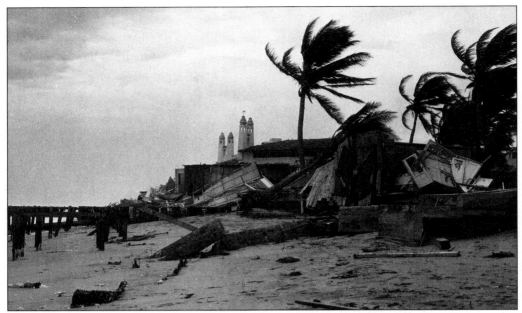

Palm Beach was not spared by the storm. The famous Bath and Tennis Club on the ocean was damaged. It had been built in 1926 by architect Joseph Urban to compete with the Everglades Club. Urban was the designer for Florenz Ziegfield. Founders' memberships were $10,000.

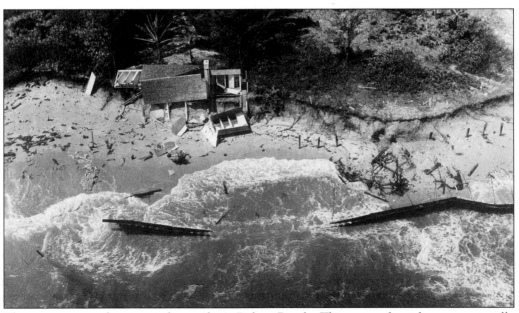

There was storm damage as far south as Delray Beach. This ocean-front home was totally destroyed. It was common and desirable to build early homes close to the water's edge. It became abundantly clear, over the years, how impractical this was.

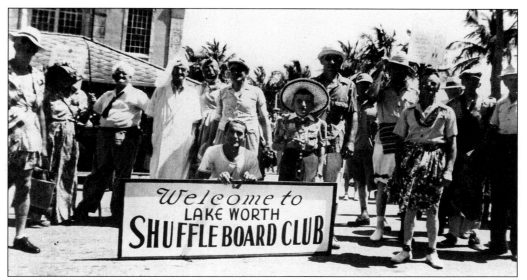

The Lake Worth Shuffleboard Club was the Southeast Coast champion in 1948. The Shuffleboard Club, with over 1,000 members, was one of the largest organizations attracting tourists to Lake Worth. Membership dues were $5 a year. Local merchants gave merchandise for prizes and were very supportive of all shuffleboard activities.

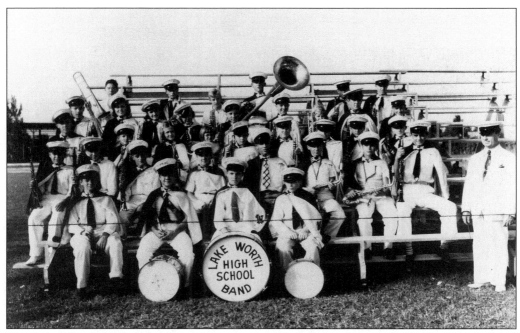

The Lake Worth High School Band was composed of 43 members in 1948. The Band played for many social, athletic, and civic occasions. In 1949 the Band participated in the New Year's Eve parade in Miami and at the Orange Bowl game New Year's Day. Joseph Lusk was the band director.

On September 2, 1948, a new Red Cross bus was dedicated at the Palm Beach County chapter of the American Red Cross on Evernia Street in West Palm Beach. The group was also marking the second anniversary of trips to volunteer at the V.A. Hospital. Former Mayor Jack Barton is at the back left.

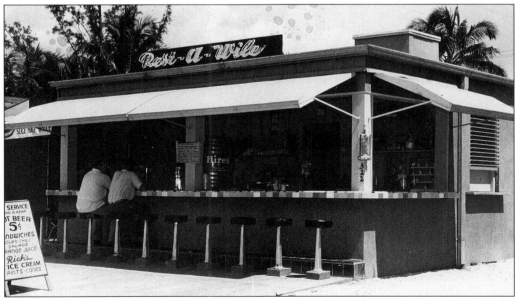

The Rest-A-Wile Diner, located at 522 Lucerne, was owned by Robert W. Stephens. It was the first drive-through restaurant in Lake Worth. It sold Hires Root Beer for 5¢, Rich's Ice Cream, orange juice, soups, salad, and watermelon by the slice.

The Fiesta Del Sol celebration began in 1948 as an annual three-day event to usher in the tourist season. It eventually became a five-day event in January and was one of the largest festivals on the Florida East Coast. Events included spectacular parades, a beauty pageant to crown the festival queen, music, square dances, fashion shows, and golf and shuffleboard tournaments.

Herb Goodman was a well-known character in Lake Worth for many years. He was known as the 135-pound shark fisherman who had caught 174 sharks from the beach with a rod and reel. Every Sunday, crowds would gather to watch him reel in another one. He had a paint and key shop that also sold tackle at 805 Lake Avenue.

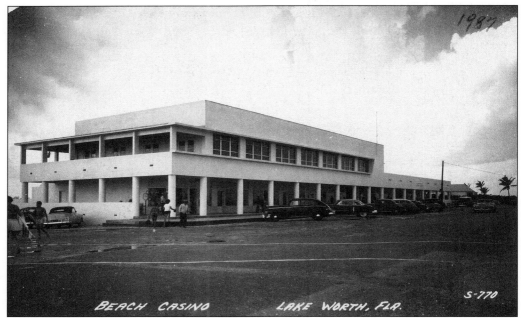

Several hundred residents, distinguished guests, and visitors witnessed the dedication of the new $250,000 ocean-front Casino. Guests filled the ballroom to capacity and danced to Dean Hudson's orchestra. Other beach improvements were additional parking and new showers, picnic areas with tables, and barbecue pits. The swimming pool had been converted from salt to fresh water.

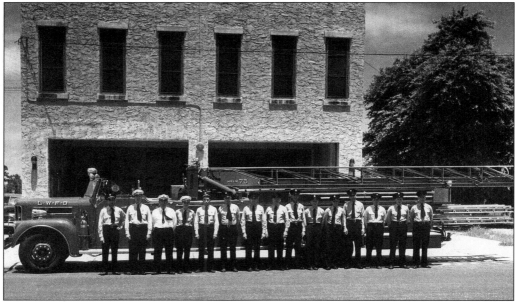

The Lake Worth Fire Department proudly shows off their new 75-foot Maxim aerial ladder firetruck and pumper in front of the station house in 1950. Not only did the men put out fires, but they also repaired broken toys and once even were called to capture a loose monkey. Chief C.E. Brouse and some of his men raced to the scene; however, the monkey eluded them.

The first bus stop benches in Lake Worth were installed early in 1950 at city hall. The group here, from left to right, is as follows: Jim McEveen (bench salesman), Andy Andrews (Falk's Service), Malcolm Baker (mayor), Frank Clark (city manager), Hank Preston (city commissioner), George Boutwell (Boutwell Dairy), unidentified, Dave Reeves (city commissioner), and Les Gunderson (Gunderson Furniture).

This building is considered to be "the oldest building in Lake Worth." It was among the 60 or so buildings erected the first year of settlement. It was located at 811 Lucerne Avenue near Dixie Highway. It had originally been built as a residence and was converted to a popular Italian restaurant in 1950 by Al Mele.

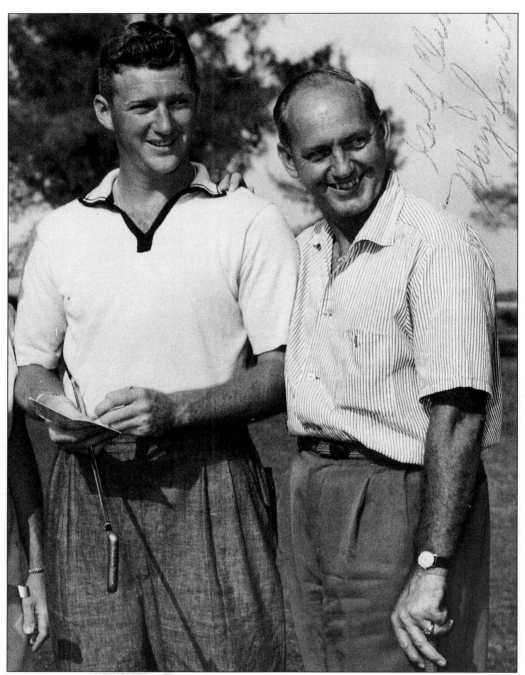

The Lake Worth High School Trojan baseball team beat Miami and won the Gulfstream Conference in 1950. Herb Score, on the left, was known for no-hit games and strike outs and struck out 16 batters in the final game. Score went on to have a spectacularly short career in the majors, due to a freak accident. Mayo Smith, at his right, was a graduate of Lake Worth High School and a former Lake Worth Rambler. He went on to manage the Philadelphia Phillies, Cincinnati Reds, and the Detroit Tigers.